Abstracts

Techniques and Textures

Rolina van Vliet

Search Press

CONTENTS

This book contains fifty detailed studies, over three hundred inspiring images and dozens of techniques and textures to help you put abstract, non-figurative painting into practice. All the studies are based directly on practical experience and will help guide you on your way to originality, freedom of expression, and finding your own personal style.

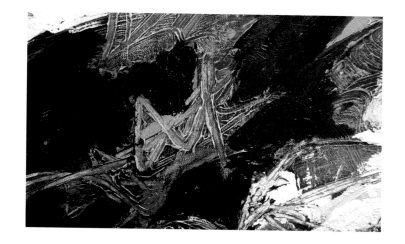

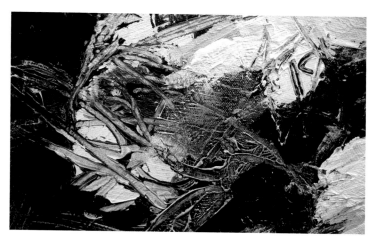

Experimental techniques can lead to a very personal 'visual language'. These techniques are used particularly by abstract painters in their search for originality and their own personal signature. Acrylic on canvas, experimental studies, R. van Vliet.

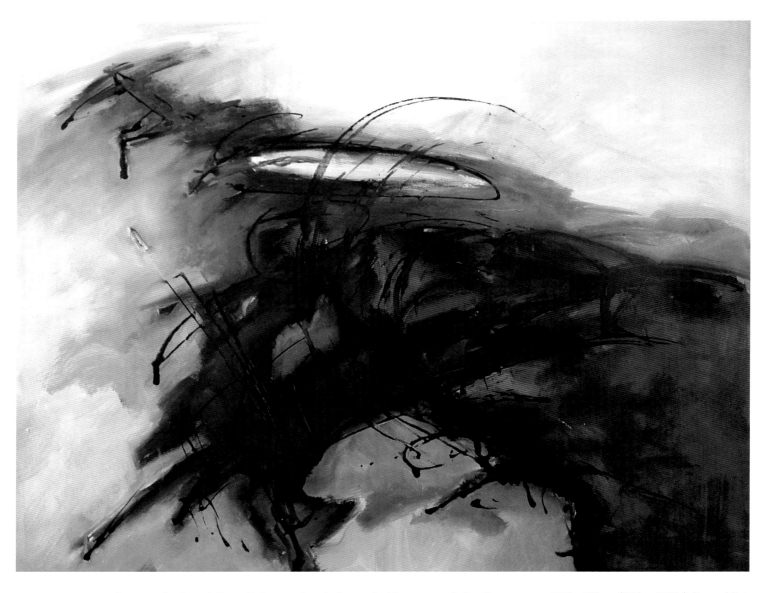

An example of a painting with large active strokes and wide movement. Acrylic on canvas, 100 x 120cm (39½ x 47¼in), R. van Vliet.

Abstracts

Techniques
and Textures

Rolina van Vliet

INTRODUCTION

As a teacher and creator of the 'Abstract Painting Method' I have written a series of books guiding aspiring artists to achieve free abstract and non-figurative painting. This book is the fourth in the series and I have assembled these particular studies to provide a concentrated focus on the technical and practical aspects of free painting in order to equip you with the tools you will need to work independently as an artist.

During my work as an art teacher, I have observed that experience with a broad range of materials, techniques and textures can have a positive effect on the free painting process. Establishing a strong technical basis can help guide and control the artistic process, particularly for those new to the subject who may still be finding their way around this intuitive style of painting.

It is my belief that one must first develop these technical painting skills before one can develop an effective style. Perfecting your technical skills will lead you to discover your own, personal 'visual language'. Your style of 'visual language' is something that is original to you as an artist and will have a powerful, expressive quality that makes your work recognisable to your audience. Painting is, afterall, more than just simply applying various techniques. It is important for all abstract painters to make their work distinctive in this way, however applying your own 'visual language' is a skill that develops through first having established a good technical foundation in combination with independent discovery and experimentation.

The studies in this book will give you a solid grounding in the techniques and possibilities involved in free painting. There is a variety of techniques to choose from depending on the materials you select and the type of effects you wish to achieve. Most importantly, the studies are geared toward reinforcing your individuality in the way you apply textures and emphasis; and the intuitive way in which you express feelings with your materials. These choices will eventually compose your personal signature, lending individuality and originality to your work. After all, this is the ultimate goal of the abstract painter.

As a textbook
Consider this book, like its predecessors, as a textbook that will help you build upon the practical techniques you learn through each stage. All of the studies and techniques come directly from practical experience, as I believe that anyone can learn how to paint abstracts if they are prepared to put in a lot of practice. Both beginners and more advanced students can work their way through these techniques and reap the benefits. I have purposely included a number of non-figurative works in the book so that the reader can detach themselves from reality and indulge in a sense of total freedom. I have also included some exercises that require only paint, without additional media, to further stimulate that all-important basic skill of painting.

When approaching the exercises, always bear in mind that these studies should be seen as playful experimentation with materials, techniques, visual elements and composition and I can guarantee that your journey will be an exhilarating and inspiring one.

Wishing you great enjoyment,
Rolina van Vliet

A NOTE OF THANKS

I would like to dedicate this book to my late partner, Sytse van Vliet (deceased July 2012).
He always gave me my space, was constantly encouraging and supported me in every
way with the creation of my books.

1 Abstract and abstraction

What is abstract?
The dictionary gives the following definition:

Abstract (Lat. *abstractus*) = removed from reality, disconnected from what is observed, intangible, not imaginable as a shape, cannot be named as an existing, concrete thing.

To abstract = to derive from what is perceived, to set apart, to remove.

Two assumptions
There are two basic assumptions within abstract painting:

A) **there is no connection with reality**.
We use elements such as shapes, colours, lines and textures to create our own reality. This is also known as non-representative, non-figurative or non-objective art. In this respect, our work is completely abstract.

B) **there is an inventive connection with reality**.
In this case, we use shapes and representations from reality and apply the rules of abstraction to these in order to create something individual and unique.

Abstract of a landscape. Without a horizon it looks like a completely abstract work.

Acrylic with sand on canvas, 60 x 80cm (23½ x 31½in), J. Holthe.

Abstraction

As abstract painters, when we depart from reality, we use abstraction mainly to make reality seem more abstract, to the point that it is barely recognisable. In this way, we use reality, but we do not copy it. The process challenges us to find a unique way of representing the things around us. Reality is therefore no more than a stimulus. We do not let it dictate which shape or colour we should use, but rather enjoy the freedom to create our own, new reality. When we use representational images from reality to create abstract works, such as trees, flowers or landscapes, we can use the following steps:

- First, simplify the subject and leave out details
- Leave out all depth features, such as shadows and perspective. We are deliberately returning to a two-dimensional representation
- Simplify the form by stylising with angular or jagged lines.
- Intentionally change the colours into non-realistic colours.
- Reduce the entire composition to a few outlines and shapes
- Create a personal, unconventional or unnatural composition
- Draw only the outlines of shapes and place these transparently on top of each other
- Use a different and unnatural texture.

In the end, there should be so little remaining of the initial image that we can easily detach the subject from its function. By doing this we will have reduced reality to abstract shapes that can then be used for study or painting. The extent to which we apply this process of abstraction determines how representational and recognisable the work is or whether it has become something abstract. The more that you move away from reality and the closer you get to total abstraction, the more personal your work will become and the more room you will create for your own artistic sensibility.

Abstracted landscape.
Acrylic on canvas, 30 x 80cm (11¾ x 31½in), P. Wiekmeijer.

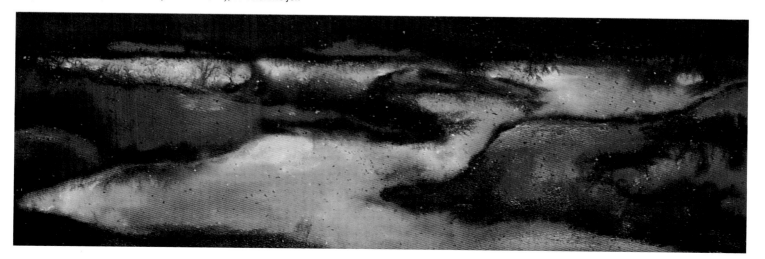

2 The 'Abstract Painting Method'

The '**Abstract Painting Method**' is a new method of study designed to convey the tricks of the trade to the aspiring artist. The method will guide you in creating your own free and expressive abstract paintings. You will learn through creating the work itself and by identifying your artistic sensibility. The method emphasises originality and personal style, which are the essential foundations for all true and artistic expression. For this to happen you first establish how to use the basic building blocks of painting to develop your work.

The building blocks of a painting
All paintings, whether they are figurative or abstract, are composed of a 'visual language'. This 'visual language' is composed of a number of visual elements. We can roughly divide these into primary and secondary visual elements. The primary elements are the more tangible concepts that lay the foundations of a composition. They help to bring the more indirect secondary elements to life.

Composition
The primary and secondary elements come together in the composition. All paintings are hierarchies, arrangements, amalgamations or a combination of these elements. This applies to both the figurative and the abstract painter. While the figurative painter must keep a grasp of reality through the details, unfortunately, the abstract painter cannot do this. The visual elements are really all that the abstract painter can cling to for guidance. That is why a strong awareness of the visual is so crucial in free painting.

We can distinguish the following visual elements:

Primary visual elements:
line
shape
colour
tone
format
texture

Secondary visual elements:
motion and dynamism
pattern, rhythm and repetition
equilibrium and balance
unity and harmony
variation and gradation
dominance and emphasis
contrast and opposition
dimension and depth
space and plane division

Design and the starting point
When you choose to create a totally abstracted work in a non-figurative style, your work has no connection with reality. Whilst it is true that your painting can flow from a certain feeling, while you are doing these exercises you simply need to focus on your relationship with colour and shape; texture and contrast; or rhythm and line. In other words, playing with visual elements is the most important basis for your painting. This is why these visual elements have been chosen as the starting point for the study programme. By learning how to recognise and use these visual techniques your 'visual language' begins to develop.

As your painting and technical skills progress over time you will begin to paint freely and intuitively.

Aim

The ultimate goal is that your work will display **artistic sensibility, expression and originality**.

Anyone who want to free painting should aim for this. Your own personal aim should not be to create an aesthetically stunning work of art, but rather to develop and exhibit the qualities of free painting.

The 'Abstract Painting Method' for everyone

Following the 'Abstract Painting Method' does not mean that you only have to paint in an abstract style. On the contrary, the method and the exercises in this book are only intended to develop your artistic qualities and skills. These are important for all painters, no matter what style they prefer.

What will you learn from the 'Abstract Painting Method'?

If you take the abstract path, you will learn how to:

- abstract and 'see' abstractly
- reduce reality to its essence and give your own interpretation
- completely detach yourself from that reality
- recognise, adjust and intentionally use the visual elements - these eventually make up your 'visual language'
- develop your internal artistic resources and your feelings for colour, shape, composition, harmony, etc.
- enjoy playing with materials, colours, lines, shapes, etc.
- trust your intuition and spontaneity
- experiment on your own and explore techniques and materials
- develop your own 'visual language' and style
- discover new ideas yourself and put these into practice
- create your own unique and original work.

The tools

As painters, we obviously use paint and other physical materials. However, the visual elements and composition shapes we use to build up our work are also part of the painter's toolbox. These visual elements are the ingredients of our work. So, learning to recognise and use these elements is highly important.

Playing with shape and colour.
Acrylic on canvas, 40 x 120cm (15½ x 47¼in), C. Goedvolk.

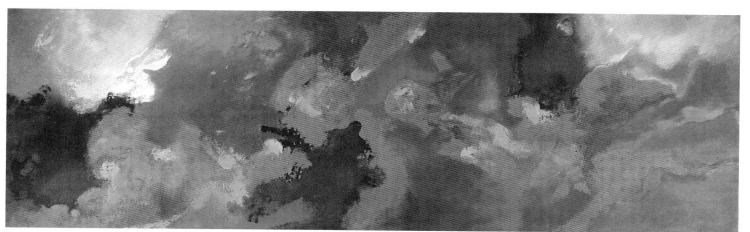

3 Primary visual elements

The line element

The line is a purely abstract detail. Lines are a means of drawing that allow us to show shapes, plane divisions and linear effects on a two-dimensional surface. As soon as we use the line in an expressive manner, it takes on an artistic role and influences the whole appearance of our work. Linear actions allow us to create the other visual elements such as texture, orientation, dimension, depth, dynamism and movement. With the line, we can achieve variety, rhythm, pattern, emphasis and contrast.

We can create lines through:
A) **linear actions** For instance, lines can be thick, thin, angular, curved, dynamic or just static.
B) **linear effects** We can also create lines or stripes using techniques that produce stripy effects such as print techniques, blowing and flow techniques, stencil, dripping and pouring techniques.

The shape element

When we think of the shape element, we think of:
A) abstract, unnameable shapes
B) nameable shapes taken from reality.

Abstract shape language

Abstract, non-figurative shapes can be roughly divided into four groups.
- Geometric shapes: squares, rectangles, circles and so forth are the basis of geometric abstract art forms such as constructivism.
- Symbolic shapes: these are visual symbols with a decorative function that are, in part, connected to a certain meaning. These are often seen in tribal and folk art.
- Organic shapes: these are shapes found freely in nature that are used in an abstract manner. For instance, think of rock formations, stones, microscopic organisms or clouds.
- Free, non-figurative shapes: these are expressive, fancy, varied shapes that are created through an impromptu and experimental painting process. We can think of expressive, constructive shapes, torn, cut, open, closed, flat or expressive shapes (in 2D or 3D) and even shapes that are large or small, narrow or wide, with or without a contour.

The language of shapes

It is a real challenge for abstract painters to develop their own shape language. Variation is an extremely elementary tool that we can use to reveal a great deal of ourselves.

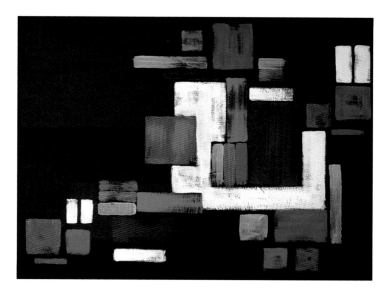

Shape, colour and texture elements in a scraping technique using a knife. Acrylic on canvas, 50 x 70cm (19¾ x 27½in), C. Ruijters.

The colour element

The visual element of colour is a source of expression that, as painters, we cannot do without. Nine times out of ten, particularly in abstract work, the colour element is the most attention-grabbing component. For a painter, colour can be considered as the messenger of a certain feeling. Colour gives our work atmosphere and character. Make sure that you are familiar with the colour concepts and colour properties. In practice, abstract painters frequently use analogous, monochrome or complementary colours.

- **Analogous** colours are the colours that sit next to each other on the colour wheel. For example, red, red-orange and orange. These colours reinforce aspects such as harmony, unity and calm.

- **Monochrome** colours are variations within a single colour family. There are red, blue, yellow, orange, green and purple colour families. These colours give unity and harmony.

- **Complementary** colours are supplementary colours. The complementary colour to red is green (yellow + blue). The complementary colour to yellow is purple (red + blue) and the complementary colour to blue is orange (red + yellow). When complementary colours are placed next to each other, the colours become more intense (contrast). However, when we apply complementary colours transparently or as a glaze on top of each other or blend the colours into each other, they become weaker. Try to make intentional use of them. Colour also plays a large role in achieving the primary visual element of tone and the secondary visual elements of space, dominance, harmony, unity, repetition, rhythm and contrast.

For more detailed information about colour, consult some of the books available on this subject.

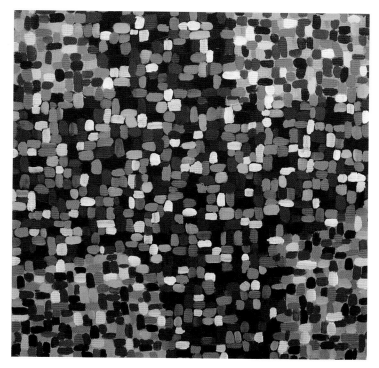

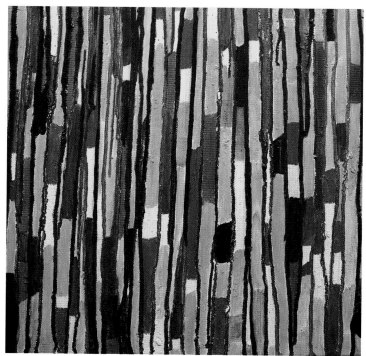

Colour, rhythm and pattern. Acrylic on canvas, 30 x 30cm (11¾ x 11¾in), G. Zwarts.

Line, colour, rhythm and repetition. Acrylic on canvas, 30 x 30cm (11¾ x 11¾in), J. Zweijtzer.

The tone element

The intensity and weakness of tone determine the strength and appearance of the work. In practice, people often underestimate the visual element of tone. This leads to flat, dull and literally monotonous work that lacks expressive power. But if tone strength is missing, this is easy to remedy. In all of the work you produce, train yourself to use a tone scale with at least three degrees of shade. That applies to both black-and-white and colour work. In all your work, check for light, middle and dark tones. Tone plays a role in variation, gradation, unity, harmony, dominance, emphasis, contrast and opposition and indicates the focus area and interest area. Alongside colour, tone contrast is the most powerful way you can attract attention in your work.

The format element

As a purely visual element, format involves the size of the shapes, the colour fields we place on the picture plane and the scale at which we depict things. For instance, we can reproduce our design at a very small scale or choose to fill the entire canvas (micro or macro format). We can also zoom in on one part of our design. Format variation within the picture plane gives us an important way of introducing variety and contrast. You can adjust the format element to the dimensions of the canvas surface or you can choose either a large, small, narrow or wide picture plane and then orientate the canvas in either a landscape or portrait direction.

The texture element

When we talk about texture, we are referring to all of the effects that interrupt and break up smooth painting surfaces. These are the varied layers that we use to build up our work. Texture is everything that we apply beneath, inside and on top of our layers of paint that adds variation, irregularities, emphasis, relief and roughness to our surface. Therefore texture is a highly distinctive and artistic element. Texture is our personal response to the material and in this way enhances our originality and individuality.

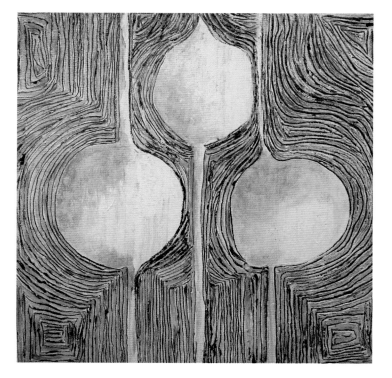

Paint texture, with French chalk powder filler and scored lines on canvas, 30 x 30cm (11¾ x 11¾in), C. Goedvolk. See also study 18.

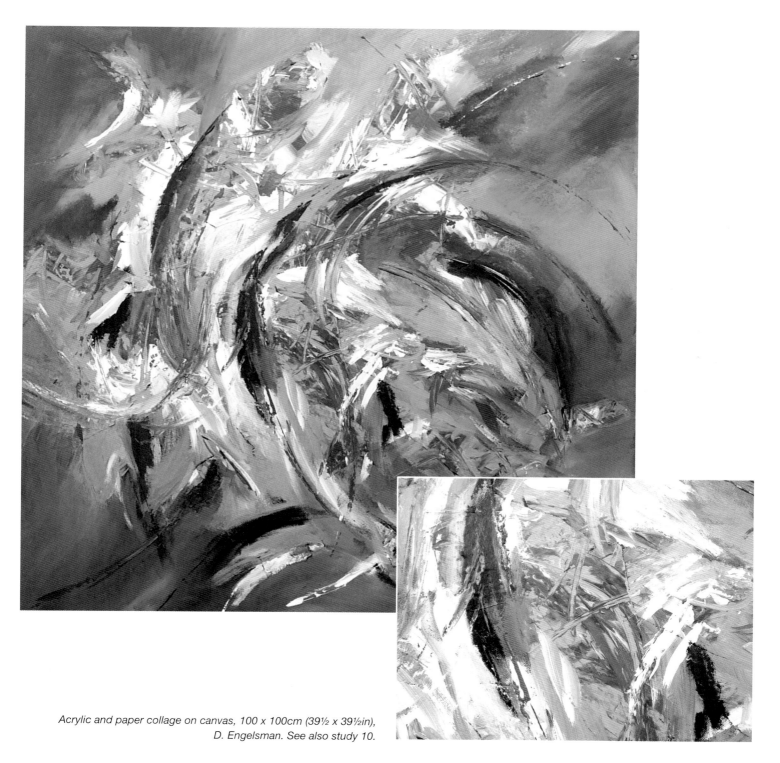

Acrylic and paper collage on canvas, 100 x 100cm (39½ x 39½in),
D. Engelsman. See also study 10.

4 Secondary visual elements

The secondary visual elements

Secondary visual elements affect the composition, its power and 'ability to speak'. An important question we have to ask is 'how do we bring the entire work together?' Learning to be aware of secondary elements can help us to impose order on our work.

- **Movement and dynamism** indicate liveliness, energy and action. Movement is actually the visual progression from one place to another. Movement attracts our gaze and leads it into, across or out of the painting. Emphasising horizontal paths gives our work a calmer appearance than when diagonal paths are emphasised. Vertical emphasis gives our work stability. Repetition and short rhythmical emphasis also suggest a sense of motion. This is because our gaze follows the rhythm and jumps from one shape to another.

- **Pattern, rhythm and repetition** shown by shapes, lines and textures that are repeated various times and are almost identical. These give a sense of rhythmical repetition. They emphasise movement and dynamism but also unity and coherence. Various techniques such as printing, scratching and stencilling can be used very effectively to show rhythm and pattern.

- **Balance and equilibrium.** As a rule, compositions require a certain equilibrium. Symmetry is the absolute form of equilibrium but it is not very surprising or exciting. As soon as we start with unequal shapes placed along the middle axis, we have to look for equilibrium. A large, heavy shape positioned on the right requires various, less heavy shapes on the left. We call this dynamic equilibrium. Balance is not just a question of visual equilibrium. It also involves tone, colour and texture equilibrium. Repetition is essential for this.

- **Unity and harmony** are excellent ways of bringing order and cohesion to shapes, lines, colours and textures. But you need a lot of experience to develop an intuitive sense of unity. We need to have the feeling that everything has its proper place and that nothing else needs to be added or removed. Connecting features and repetition are important ways of establishing cohesion. There is an art to bringing together diverse elements so that they appear as a whole to the eye. Similarities between lines, shapes, colours and textures help strengthen unity and harmony.

- **Variation and gradation** remind us that a painting needs to have more than just the same repeated shapes, colours and features. From time to time we will have to force ourselves to develop a new 'visual language' in order to avoid over-reliance on the same styles. There is nothing as dull as a work that uses the same brush strokes or structures from start to finish.

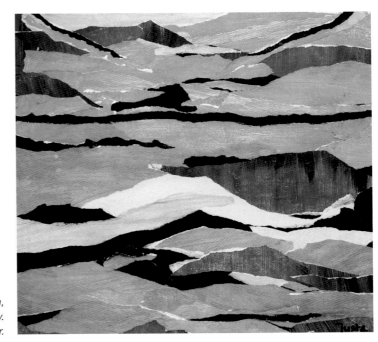

Movement, rhythm, repetition, equilibrium, variation, gradation, unity, harmony.
Paper collage on canvas, 30 x 30cm (11¾ x 11¾in), J. Zweijtzer.

- **Dominance and emphasis** are very important for creating appealing work. They determine what is the most important part of the work and allow it to shine through using colour, shape, line or texture. Dominance can involve the focus area. We can also see dominance at work when a calm area attracting little attention is finished in a dominant colour. Dominance is a way of helping you to choose what you want to emphasise.
- **Contrast and opposition.** Contrast is attention, action and tension. Any flat or monotonous painting can be revived using contrast. Contrast is the difference between silence and expressive eloquence. We need contrast to show our focus area. Contrast attracts attention and cannot be avoided. Contrast makes us step into a painting, wander away from it and then come back again. Contrast is mainly based around a specific opposition. This could be the difference between large and small, light and dark or a smooth and textured surface, for example. We create contrast using the primary visual elements.
- **Dimension and depth.** Dimension involves depth. Does our work look two dimensional or three dimensional? Is it flat or does it appear to have extra depth? To create depth, we can use techniques such as geometric line perspective, format and colour perspective, aerial perspective or overlapping. It goes without saying that when we do not want to show depth, we should avoid these effects. Generally speaking in abstract work, we try as far as possible to avoid showing depth, as this is something associated with the depiction of real-life objects. However, we do use depth effects created through the use of texture and relief.

- **Space and plane division** Depending on the way we have divided our picture plane, our work can give the impression of space. Smaller shapes that are surrounded by a large, empty and free field suggest ample space, calm and silence. Objects that fill the canvas do not give us an impression of any further space. Lines that lead us to the edge of the picture plane suggest that there is further space beyond the plane's edge. Closed shapes and colour fields isolate themselves from the surrounding space. A composition with separate shapes gives each one individual space, but it loses cohesion. Shapes that touch or overlap each other give the effect of the space being pushed away. Plane divisions can have a lot of surrounding space, or very little. Furthermore, we are also able to show space as positive or negative space.

We need rhythm, dynamism, contrast, variation, dominance and emphasis to enhance the focus area. These elements give extra tension to our work and make it more attractive. Repetition, balance, equilibrium, harmony, unity and cohesion bring calm to our composition.

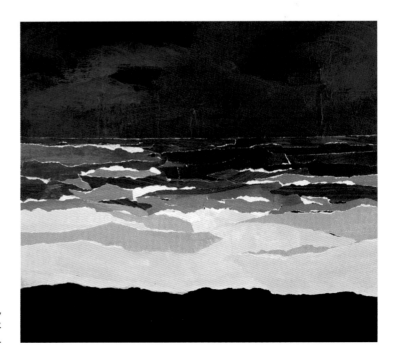

Right: variation, dominance, emphasis, contrast, opposition, dimension, depth, space, unity, harmony.
Paper collage on canvas, 30 x 30cm (11¾ x 11¾in), R. Arends.

5 Composition

Composition is the organisation and arrangement of the visual elements that, when put together, make up our 'visual language'. The plane division, in particular, is the framework and the starting point for our painting process. There are various ways to create a composition. Two common alternatives are:

A) a direct and extremely spontaneous method through experimentation or rough sketches.
B) a thought-out, constructed and deliberate design.

There are two ways to start a composition depending on what you want to centre your piece:

A) with a focus, where the active and passive areas complement each other.
 The focus composition.
B) without a focus, in which the active or passive areas are evenly distributed across the entire picture plane.
 Compositions that fill the whole canvas.

A) Focus composition

The focus areas are those parts of our painting to which we want to give our full attention and wish to emphasise in our image. We can highlight this active area through the use of lines, shapes, format, colours, tones or textures. This means that we give less emphasis to other areas, which are the passive areas. Our focus area is actually a combination of interest areas and acts as a guide for our gaze and the direction our eyes follow. In general, we position our interest areas closer to the centre, but never exactly in the middle of the picture plane. We need to make sure that smaller and weaker focus areas lead our gaze to the edges of the picture plane which will allow us to see the painting as a whole.

Active/passive

A composition gains power when there is a certain exchange between its active and passive areas. When we talk about active areas, we mean those areas of the painting where something is happening, the places that attract our eyes, the focus area. This is where we enter the painting and where there is contact with the observer. We can understand the passive areas as being places that exude calm. These are the areas that attract less of our attention and, as a result, emphasise the active area. They provide calm and space and allow our eyes to explore the remainder of the painting. It is important that we always see the painting as a whole. For this reason there should always be a certain amount of contact between the active and passive areas. However, this does not mean that nothing should happen within the passive areas. The passive areas are only 'calm' in relation to the more intense action in other parts of the painting.

B) Compositions that fill the entire canvas

When we create a work where the action is vibrant across the whole picture, we cannot actually show one focus area. In these types of work, the features that reinforce action are colour, tone, texture, rhythm, emphasis and contrast and these are uniformly applied across the whole surface. This means that our attention is pulled equally to all parts of the canvas. Abstract painters are often faced with this type of choice. Painters who work with materials, texture aficionados and even constructivists often have a strong preference for compositions in which intensity is equally distributed across the canvas.

A composition occupying the entire area where shapes, colours and emphasised areas have been evenly and equally distributed across the entire canvas. Acrylic on canvas, 50 x 60cm (19¾ x 23½in), E. de Groot.

Plane division

Plane division is the basis and foundation of the composition. When introducing a plane division, we use symmetry or asymmetry as a starting point. We can use the radial, grid, cruciform and frame compositions. Circular, triangular, diagonal, horizontal, vertical and even two different overlapping compositions give us further possibilities. Look into the many options available so that you can start your work with an exciting composition.

Application techniques

You can apply your plane division by means of:

A) a shape composition. This occurs frequently when abstracting figurative shapes.
B) a line composition. This is an excellent way to divide the plane.
C) a colour composition. Using colour distribution as a starting point.
D) a texture composition. We mainly come across this in free experiments and underpainting.

In all cases, you can show your composition with

A) a free, sketched-out design or
B) a structured, tight and clearly constructed design.

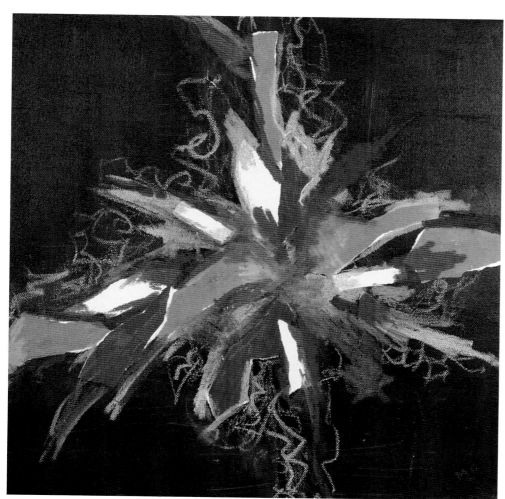

Radial composition with central, active focal point with passive surrounding space.

Mixed techniques using paper and pastel on canvas, 40 x 40cm (15¾ x 15¾in), M. Onnink.

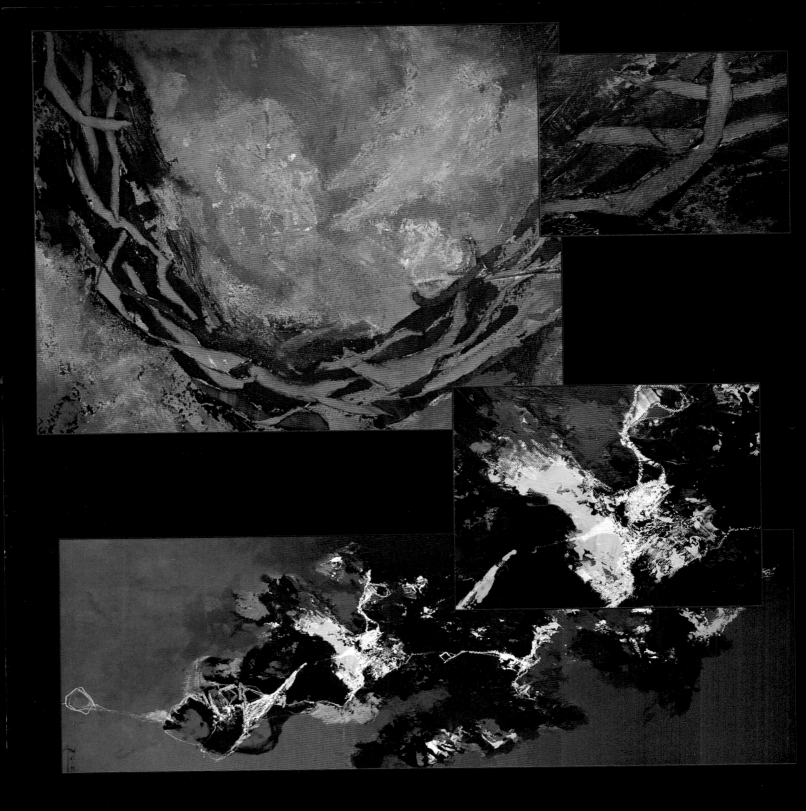

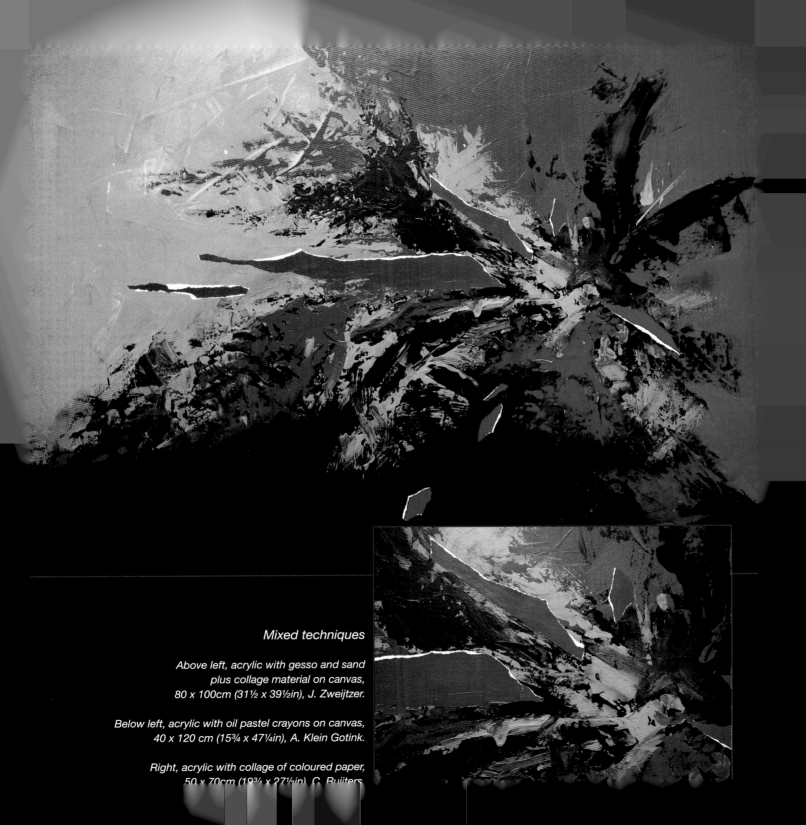

Mixed techniques

*Above left, acrylic with gesso and sand
plus collage material on canvas,
80 x 100cm (31½ x 39½in), J. Zweijtzer.*

*Below left, acrylic with oil pastel crayons on canvas,
40 x 120 cm (15¾ x 47¼in), A. Klein Gotink.*

*Right, acrylic with collage of coloured paper,
50 x 70cm (19¾ x 27½in), C. Ruijters.*

6 Play and practice

Play is the best way to activate our artistic sensibility. It is the most open and unrestrained way you can learn. Play allows us to reach our inner gifts and talents, especially when we are able to act on the basis of spontaneity. It gives complete freedom for all forms of inspiration, intuition and imagination. Play is part of childhood but is forgotten by many adults and substituted by rational, goal-oriented actions. That is why we need to re-learn how to play. This has nothing to do with childishness, but everything to do with reaching and activating your inner resources. Play sets into motion a special chain of characteristics that are extremely important for developing artistic qualities. Not least because, as adults, we have forgotten what play can release from within us.

Play is:
- experimenting, discovering, exploring and learning
- a healthy curiosity
- letting go of reservations and surprising yourself
- trusting yourself and learning to value yourself
- spontaneous and intuitive
- fantasy, invention and imagination
- pleasure and forgetting everything around you
- free from stress and pressure
- without bounds, creative, expressive, original and personal
- a mixture of gifts, talent, knowledge and experience
- dedication, motivation, involvement, passion and enthusiasm.

No other type of exercise activates as many qualities as play. **Play brings out what is inside you.**

Practice

What does creating an abstract painting demand from us? A great deal! Abstract painting is not as easy as people often think and is certainly not a style of painting in which to hide a lack of talent. In fact, it is an extremely challenging form of painting. First, it demands far greater expression and initiative than when we paint from reality as we are lacking all external visual information. After all, as abstract painters, we work without the support of the detail provided by reality. We have to find everything independently by immersing ourselves in our fantasy, intuition, imagination, knowledge and experience. We have to invent and build our own composition. We have to design shapes, find colours and determine the division and structure on our own. The way we approach this comes entirely from inside us and we must work hard at it. With abstract painting, we have to be able to interpret everything ourselves. In this sense, abstract painting is not straightforward. It is extremely challenging and that is where the excitement lies: we discover who and what we are and what hides inside us.

What knowledge and skills do you need to be able to create an abstract work? You need to:
- plan out your own composition and plane division
- understand and choose colours
- know about visual elements and design
- design your own shapes, features and 'visual language'
- know about materials, techniques and textures
- have knowledge and experience of the work sequence in creating the work.

That is why you need to learn about your 'tools' and thoroughly study visual elements, 'visual language', composition, colour characteristics, techniques, textures and styles to be able to freely use all of the possible options.

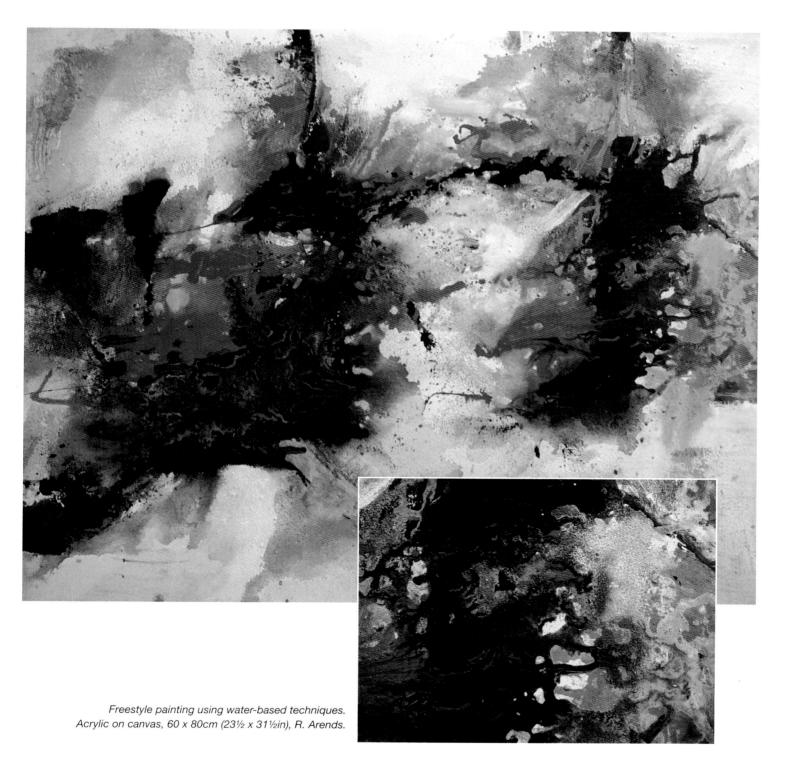

Freestyle painting using water-based techniques.
Acrylic on canvas, 60 x 80cm (23½ x 31½in), R. Arends.

7 Getting started

As an abstract painter, you can start the painting process with:

A) **An experiment.** To work in this way, you start without a fixed design in mind. The aim is to discover and investigate the possibilities of certain actions and the effects that can be achieved by using a variety of materials and techniques. This is pure and unrestrained play. This method is particularly suitable for the non-figurative and material painter.

B) **A design, idea or concept.** You work by focussing on a certain idea or concept. You usually start by determining the composition, plane division and other external features such as colour and texture. It is a starting point from which you continue the painting process and technical execution. Constructivist painters and painters who work with abstraction feel more comfortable with this way of creating work.

Techniques are shown during the painting process for both starting points (A and B). In method A, the experimental way, the emphasis is more on 'what can I do with my materials?' whereas in the design way (B), the stress is on 'how can I realise my idea?'. Whichever way you choose to follow, the technical process of painting ultimately determines the visual impact.

The painting process

The painting process is a huge meeting point where everything connected with painting comes together: techniques and experiments, texture and 'visual language', visual elements and composition, ideas and concepts, feelings and emotions, talent and experience. It is down to you to properly channel these. It may help you to think through the work sequence while preparing your work.

Working to a design. This design was created with pieces of coloured paper.

Right, an elaboration in acrylic on canvas, 50 x 60cm (19¾ x 23½in), E. de Groot.

An experimental work.
Pure play with...
Freestyle Painting,
80 x 80cm
(31½ x 31½in),
E. de Groot.

.

Far left, detail.

Left, final result.

Below, build-up stage.

Freestyle *In this book, I have focussed mainly on techniques which enable us to create our own 'visual language'. These are largely free techniques that give us the space to develop our own surprising and unique actions and form the basis of individuality and originality. This is real painting with a personal touch, the type of painting that allows us to stand out – our ultimate goal.*

8 Structuring your work

It is good to get into the habit of building up your work as a series of layers. As an example, here is a possible work sequence you can follow for free expressive non-figurative painting:

Before you begin
Determine the composition, the focus on active and passive areas or the non-focus of the entire area.
Determine the plane division.
Determine your colour palette.
Determine the techniques and textures you will use.

Preliminary work
Underpainting (if desired).
Background texture (if desired).
Allow the background to dry.

Painting process
1 Plane division: draw or sketch out the composition on the background (if desired).
2 Apply colour on three layers*.
 • First colour layer: free and separate colours with only occasional mixing. The aim here is to achieve the right colour division.
 • Apply the second layer of colour, wet-on-wet and deliberately choose colour mixtures and emphasise some areas. The aim is to create a sense of unity between the colours and to introduce cohesion and power.
 • Apply the third layer of colour, wet-on-wet, using greater colour variation, subtle details and tone values.
3 First reflection. Stand away from your work and evaluate the initial design.
 Use the primary and secondary visual elements to check and determine what should happen.
4 Adjustments, changes, variation.
5 Strengthen or weaken the colours and contrasts. Introduce tranquillity and unity between the active and passive areas.
6 Second reflection.
7 Details of final textures, emphasised areas, calm areas, finishing off.

Final reflection and conclusion: is it any good, should I exhibit or discard it, or does it need further adjustments?

*In phase C2, the colour scheme can range from light to dark; dark to light; or from diluted and transparent to covering and opaque. You can also build up the colour scheme for each colour. If you do that, start with the lightest colours and finish with the strongest colours. Incidentally, you should assume that, over time, you will not consciously follow this type of painting process because, as you gain experience, your workflow will become spontaneous and intuitive. In practice, you should always adapt your workflow, skipping over or adding stages, depending on the idea you wish to realise.

What is important is that you never consider a design or work sequence as binding. In other words, don't let it become a hindrance; the 'Abstract Painting Method' encourages unrestricted action.

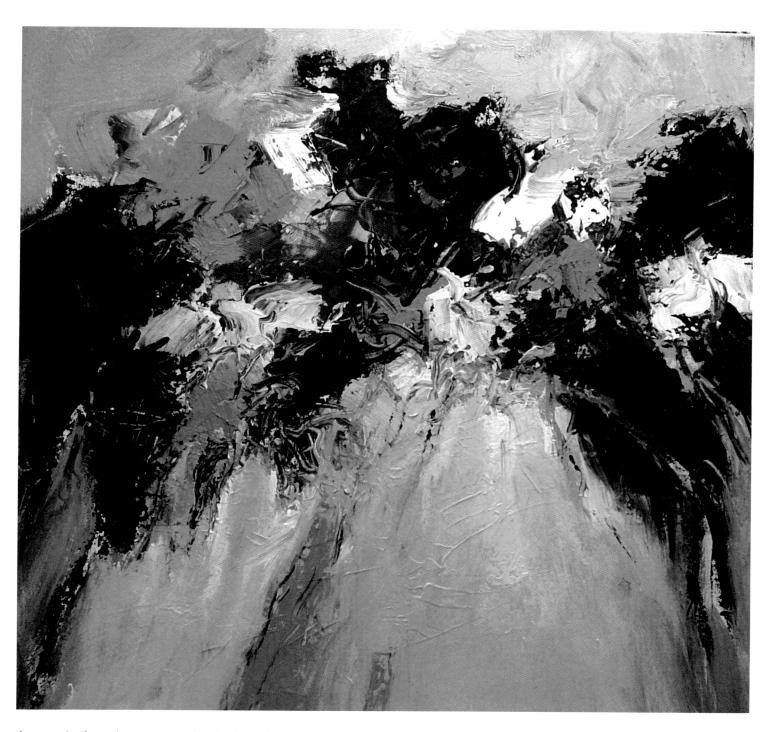

An example of a work sequence as described on p.26. Acrylic on canvas, 80 x 80cm (31½ x 31½in), R. van Vliet.

9 Study information

Having reached this stage of the book, you have more than enough information to make a start on the series of studies and techniques that I have compiled. After all, learning to paint is still a practical activity, so it is time to get working and experience what abstract painting can mean for you.

Technique is about more than just applying paint. **Technique is dealing with materials, visual elements, composition, design and workflows.**

That is why you will find detailed information on all of these in each of the study descriptions.

Study information
All of the lessons contain practical information in the following format:
- **Study number:** the technique which the study will focus on.
- **Study task:** information on the special features and aim of the study.

- **Materials:** a summary of the materials that you can use to carry out the study. Unless otherwise stated, you will always need to use acrylic paint, acrylic brushes, pallet knives and a stretched linen or cotton canvas for the studies shown in this book. If you prefer, you can change the materials or add additional ones.
- **Techniques:** the specific techniques used in the study.
- **Visual elements:** the most striking visual elements and concepts that appear in the study. Incidentally, other elements will nearly always play a role alongside the visual elements mentioned, so bear this in mind.
- **Composition:** key features of the composition you are working on.
- **Work sequence:** the workflow stages are an important part of any study. This is the sequence of steps you can take to achieve a certain effect or appearance. Naturally, you can also vary these stages and choose to follow your own ideas.

Experimental works in a composition that fills the entire canvas. Acrylic on canvas, 70 x 90cm (27½ x 35½in), M. van Woudenberg (left and right).

Illustrations

Each study task is accompanied by one or more illustrations. You should only think of these illustrations as a visualisation of the study. It must be stressed that they are not intended to be copied. In other words, you will do the study entirely your own way on the basis of your feelings for colour, shape, composition, etc. I have intentionally not mentioned the word 'example' because this suggests copying. I have instead used the word 'illustration' as the aim of the image is to support the text and help you to visualise the study task. I strongly advise you to close this book and use your own ideas as soon as you begin the study task.

The images in this book are mainly in relation to works created by my students in response to the described study task. I have also included other works of art, which were made specifically for these tasks, as well as further demonstrations to illustrate the techniques.

Keep the following points in mind.

- Unless otherwise mentioned, all of the techniques and studies described are intended specifically for acrylic paint. In many cases, if you prefer, you can also carry out the study task with other materials such as watercolour paint, oil paint or gouache.
- The studies have not been arranged in any particular order in relation to their level of difficulty or techniques. You are totally free to choose what you work on; choose whichever study most appeals to you and get started. You will find some of the studies difficult and others extremely simple and straightforward.
- The time required for each of the studies varies. Some of the studies do not require more than half an hour, whereas others may keep you busy for a whole day.
- The techniques and work sequences are repeated in other studies, though often with a different emphasis and in a different combination. The more frequently you repeat something, the easier it becomes to use intuitively and, as an expressive painter, that is something you need to do.
- All of the study tasks are intended to be used as practice exercises. This means that the results are never intended to be works of art, but rather a representation of your creativity, artistic sensibility and originality.

- There is a risk that you will follow the lessons in this book too rigidly and see the descriptions as binding. That is most definitely not the intention. Above all, you should allow yourself the freedom to use your own ideas and creativity in the study tasks. In this way you can avoid becoming dependent on tasks set by others. As an independent artist, you are ultimately obliged to develop your own ideas.
- This book is primarily concerned with the techniques of the free-painting process, which is the way that abstract painters, in particular, work. These largely involve specific actions that you will not find in regular books focussed on working with real-life painting. You should mainly consider the techniques in this book as the technical methods that abstract painters choose when looking for their own discoveries. These are the actions, combinations and effects that enable the painter to develop their own 'visual language' and create unique and exciting work.

10 Technique and texture

In practice we are largely occupied with technique and texture; the process that allows us to visualise our ideas. Depending on the materials and actions, we make use of techniques

> **without texture** and
> **with tactile or visual texture.**

In addition to being able to see tactile texture, you can also feel it. With tactile texture there is a relief effect which is mainly produced by fillers and collage materials.

A visual texture can be seen but we cannot always feel it. This is created using techniques such as pencil shading, dripping and pouring techniques and effects using salt.

Technique and texture are determined by:

Materials. We can paint using
1 paint without any added substances or
2 paint with added substances, which we can apply beneath, inside and over our work. These substances, such as texture pastes, sand, sawdust or collage materials, roughen and liven up the surface in both visual and tactile terms.

Actions that lead to a surface
1 without texture, graphical, smooth and even or
2 with texture, where we add irregularities to our work using a brush, knife or other tool. Think about techniques such as scraping, scoring, sgraffito, knife techniques and expressive brush techniques.

Texture timing

Although in practice it is important to know how you can apply a texture, it is more important to know when this should be done. You can apply textures at three different points during the painting process:

- **Before** painting on the canvas, as a sort of underlayer.
- **During** the painting process in the paint layer.
- **Afterwards** when the work is nearly completed, as an added emphasis or *finishing touch*.

In the descriptions of the techniques and the study tasks, I have shown when the texture can be applied during the workflow.

Texture – a powerful visual tool

Practice teaches us that we should use texture frequently, particularly in abstract, non-figurative painting. This is because we are not painting a recognisable real situation and therefore must provide colours, features, shapes, effects and textures that create 'visual language'. Playing with texture leads us to the unexpected with intriguing effects. It provides contrast and dynamism and makes dull areas active, energetic, lively and exciting. Texture is a great source of direct inspiration. It activates our imagination, creativity and expressiveness. Texture takes our paintings to a higher level of artistry. When we are able to put just a little of that into our work, we are on the right path.

Free and expressive techniques

For this reason, the studies described in this book focus particularly on free and expressive techniques. These techniques stimulate experimental free actions in particular, enabling us to discover an original 'visual language' and to develop our own personal signature. This is where the power of abstract painting lies as the basis for expressive, artistic and original work.

11 Technique in pictures

Technique is a goldmine for creative spirit.
Technique is playing with materials and texture.
Technique is the way to achieve an original 'visual language' and a personal signature.
Technique is the moment that we take action and visualise our ideas.
Technique is the painting process in which we intuitively and instinctively express our ideas, feelings, mood, nature and spirit.

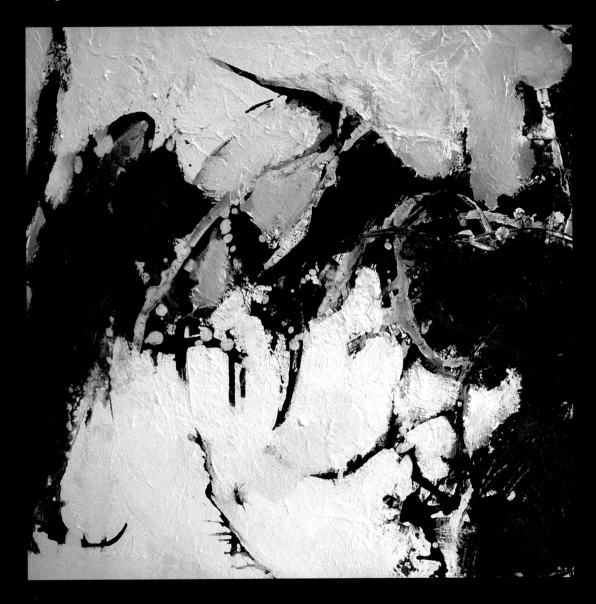

Water-based and mixing techniques

Since we can dilute acrylic paint with water, we can use watercolour techniques such as wet-on-wet, wet-on-dry, the wash technique and the glazing technique. By diluting acrylic paint with water we can create the effect of colours that flow into each other with soft edges and chance mixing. In addition to diluting with water, it is also advisable to add acrylic medium to maintain the adhesive power of the acrylic. We can also use watery paint to introduce features such as splashes and strokes. Whenever we do this, we use our own judgement to determine how much to dilute the paint.

We can use:
- flow techniques, the paints flow into each other, wet-on-wet, chemical mixing (B,C)
- glazing, painting watery paints over each other, wet-on-dry, an optical mixture (J)
- drip techniques, allowing watery paint to flow in lines. You can also use a spray bottle containing water to help with this (F)
- spatter techniques, tapping and striking using a brush filled with liquid paint (A,L)
- binding techniques, using clean water to bind paints that are still wet (E,H,K)
- working with ink and liquid acrylic paint (G)
- pouring techniques, applying liquid paint using a watering pot or can (I)
- spray techniques, using a bottle with a thin opening (D)
- atomiser technique, applying a fine mist of paint over the work using an atomiser or spray bottle
- effects using salt (M).

Note: When using water-based techniques, place your work flat on the table. If you want the water to run down the canvas, as in the drip technique, either position your work vertically or rock it back and forth in the direction you want the paint droplet to run.

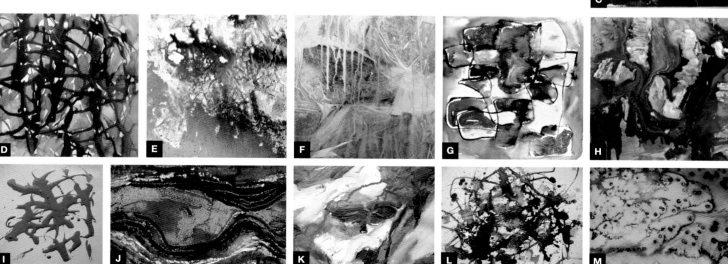

Mixing techniques

Acrylic paint in its pure form has a very intense colour. The more that you vary your colours, the more exciting your work will become. It is a good idea to become familiar with the various mixing techniques. The way that you mix your paint will have a great effect on the final result. It is recommended that you work in the most expressive way you can and do not over-mix your colours. In addition to mixing on a palette using a knife or brush, I particularly recommend that you get to grips with mixing your colours directly on the paper or canvas. This will enable the expressive 'visual language' to appear that is enjoyed by abstract painters.

There are a variety of techniques for mixing.

Chemical mixing (always wet-on-wet):
- mixing on the palette to create a pre-determined hue
- mixing on the canvas using a brush or palette knife; this creates spontaneous mixtures, shades and visual emphasis (A,B,G)
- mixing using colour blends by gently brushing colours into each other using a cloth, brush or sponge; this is soft mixing (E,D)
- mixing; using water to bring colours together (I)
- flow technique; the watery paint flows down the canvas and finds its own course (C,F).

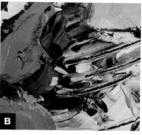

Optical mixing (always wet-on-dry):
- glazing, applying watery acrylic paints over each other
- pointillist style, placing pure colours next to each other; expressionist ways of working (K)
- hatching lines (H)
- visual mixture; you can use scoring to bind colours to each other
- dry brush or broken colours; using a dry brush and a small amount of paint to brush gently over the dry background so that the underlying layer appears through the paint (J).

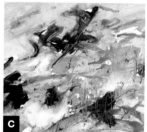

So, there are:
soft mixtures, with flowing colour transitions, and **hard mixtures**, where the painted areas scarcely touch each other and, through instinctive actions, can develop into an expressive 'visual language' with abrupt, unexpected colour transitions and features.

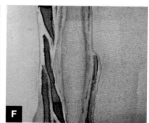

STUDY 1 Drip technique

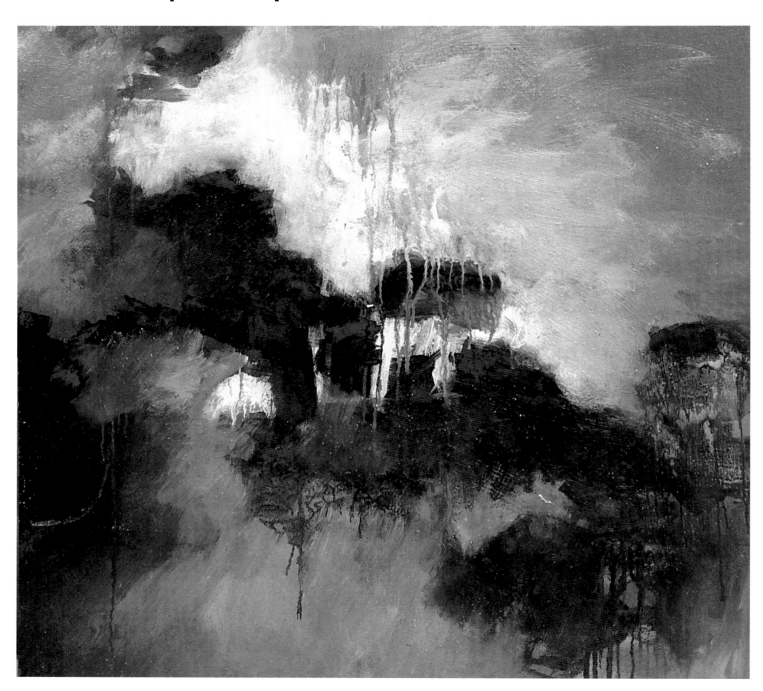

Study task
Create a free work in which the drip technique plays a visually distinctive role.

Materials
Canvas, acrylic paint, palette knife, brush.

Techniques
Apply the drip technique (allowing trails of watery paint to flow down the canvas), a covering technique with opaque paint (see p.53) softly blurring or smoothing the transition areas.

Visual elements
Line, shape, tone, colour, texture, contrast, emphasis, harmony, unity, equilibrium, cohesion.

Composition
Design a composition with a diagonal focal point in which the texture of the drip technique provides the necessary emphasis and variation.

Work sequence
1 If you prefer, you can sketch the composition on to the canvas first.
2 Build up the work by roughly marking out several shapes diagonally, in colour.
3 Build up the colour in the surrounding space and gently brush the colours into each other.
4 Work on the free shapes in the focal point using a palette knife with a second layer of paint and a different hue.
5 Start with watery acrylic paint to create the drip effect. While doing this, make sure that light colours flow over dark colours and vice versa.
Try to control the drip technique and apply it in the correct place. Do not forget to remove any excessive lines using opaque paint, otherwise known as the covering technique (see p.53). Show that you are in control.

Acrylic on canvas,
80 x 80cm (31½ x 31½in), R. van Vliet.

STUDY 2 Sponge technique

Acrylic on canvas, 30 x 60cm (11¾ x 23½in), L. Sueter.

Study task
Create a work using watery paint and a sponge to apply the paint.

Materials
Canvas, acrylic paint, sponge, fine brush for emphasis.

Techniques
Use a sponge and watery paint in this piece. Wipe the sponge vertically down the canvas. This will add many other subtle colour variations. You can complement this by using the stencil technique and wiping the sponge with paint over the stencil.

Visual elements
Shape, colour, line, tone, variation, harmony, unity, cohesion.

Composition
When painting, only wipe the sponge vertically over the canvas; a vertical emphasis gives equilibrium to a horizontal, rectangular canvas.

Work sequence
1 Position your canvas horizontally in front of you. Dip the sponge in paint and sweep over the canvas, from top to bottom.
2 Add other colour features and wipe them into each other using the wet-on-wet method. Work this into a flowing colour transition.
3 You can also tilt the canvas back and forth to allow the colour to flow in a certain direction.
4 For emphasis, you can use a fine brush to add line features and paint droplets into the wet background. If you wish, you can also drip clean water on to the canvas.

Variation
As a variation, you can dab a sponge on to a stencil and apply patterns to the dry backgroundDabbing with the sponge will create a texture effect. You can add fine lines by making score marks in the wet paint. Try to find other ways to bring the image to life.

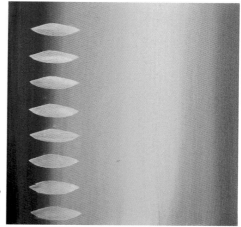

Demonstration paintings, sponge technique with stencil technique, R. van Vliet.

STUDY 3 Pouring technique

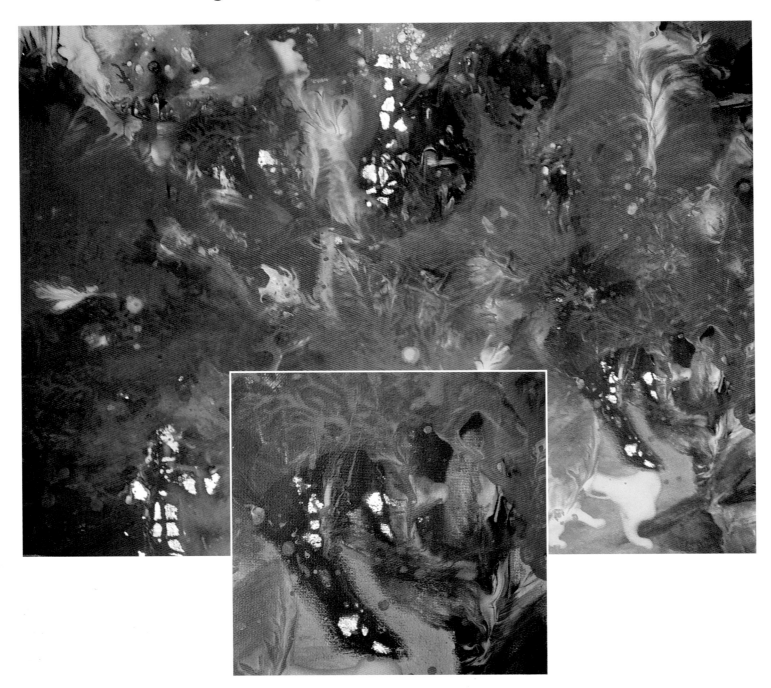

Study task

Create a free work in which liquid paint is allowed to flow through successive layers and thus determines the composition.

Materials

Acrylic paint, canvas, brush, watering can, jug or small bottle.

Techniques

Apply the pouring technique: using a can or jug. Dilute the paint with water and pour this on to the canvas. Tilt the canvas back and forth to guide the path of the paint. Repeat with other colours. Always allow the previous colours to dry first in order to keep clear, pure hues.

Next use the flow technique by applying paint on to the canvas that has been diluted with a small quantity of water. You should work wet-on-wet to allow the colours to flow into each other. Use the covering technique to finish (see p.53).

Visual elements

Colour, texture, tone, dynamism, unity, harmony, contrast.

Composition

Do not sketch the composition in advance, but allow it to appear as you apply the paint.

Work sequence

1 For this work, you will not use a pre-determined plane division or composition because the shape and plane division will be determined by the path made by the liquid paint. You should literally allow the process to take its own course.

2 Start by pouring the lightest colour on to the canvas, followed by darker and/or contrasting colours. Always allow the colours to dry.

3 Mix the colour fields with diluted paint to connect the areas between the colour regions. Your work will usually contain sufficient paint for you to bring the colour fields together using a brush and water and so add colour to the surrounding area.

 This type of work requires a lot of experience and patience. In particular, you have to learn how to control the paint in order to avoid creating a mess.

4 Finish off areas using opaque paint to introduce a sense of calm to the image.

Acrylic on canvas, 60 x 80cm (23½ x 31½in), R. Arends.

STUDY 4 Flow-painting technique

Study task

Create an experimental study using highly diluted acrylic paint.

Materials

Canvas or paper, acrylic paint, brush, fine brush.

Techniques

Use the flow-painting technique to create the entire work allowing highly diluted paint to run down the canvas and find its own path. Then use a line technique to add emphasis. If you prefer, you can allow the lines to run down and add droplets of paint for emphasis. Work using the canvas in a horizontal position.

Visual elements

Line, colour, spots, tone, contrast, harmony, unity, emphasis.

Composition

The composition is created while playing with water and paint and is dependent on the flow technique used and the emphasis given.

Work sequence

1. Prepare the paint by diluting the various colours you want to use in beakers or dishes.
2. Begin by applying the lightest colour.
3. Follow this with the other colours and try to get the colours to mix in certain areas.
4. You can repeat this to give the colours greater power by using less diluted paint.
5. Allow droplet trails to appear by holding the canvas in a vertical position for a while. You can also add droplets separately.
6. When you add droplets of clean water, you create so-called 'edge darkening'.
7. Using the wet-on-wet method, finish off by adding line emphasis using a fine brush with undiluted paint.

Liquid acrylic on canvas, 60 x 80cm (23½ x 31½in), A. Stuivenberg.

STUDY 5 Working with water

Study task
Create a study using very watery paint as a sketch background for abstracted shapes.

Materials
Canvas, watery acrylic paint, Indian ink, brush, fine brush.

Techniques
Apply the line drawing technique using ink on the wet paint, the flow technique, and the wet-on-wet technique. Start with the colour fields or with an ink drawing.

Visual elements
Line, spots, colour, tone, contrast, dynamism, texture, unity, cohesion.

Composition
Arrange the shapes in the centre of the composition and around the image plane, leaving little space remaining.

Work sequence
1 Sketch a number of shapes or figure studies on paper as hand exercises. Use a fine brush and watery Indian ink.
2 Once your sketching is accurate, move to the canvas and create another impromptu sketch.
3 Allow the drawing to dry for a while.
4 Work the whole canvas with watery, watery acrylic paint and, as you do this, allow the colours to naturally flow into each other. As well as the shape, cover the surrounding areas. However, you should also intentionally leave some areas open, so as to retain the white colour of the canvas.
5 If you wish, add several line features to this using highly diluted ink, wet-on-wet.
6 Leave the remainder of the canvas unpainted. The white, masked-out areas in the centre of the canvas act as a link between the white edges and the coloured area and in this way strengthen the cohesion.

Technique studies using liquid acrylic on canvas, 30 x 60cm (11¾ x 23½in), R. van Vliet.

STUDY 6 Mixing with gel

Study task

Create an expressive work in which the paint is thickened with gel medium.

Materials

Canvas, acrylic paint, gel medium, palette knife.

Techniques

Use the gel to thicken the paint and apply with a palette knife. Work using the wet-on-wet technique, which will allow the colours to be brushed into each other. Clearly show the effect of the mixing. Touch the other colour with a single dab. Do not brush the colours into each other too much.

Visual elements

Shape, colour, texture, variation, contrast, unity, cohesion.

Composition

Sketch a composition with free shapes as a focal point in the centre area.

Work sequence

1 If you prefer, sketch your composition on to the canvas first.
2 Thicken your paint using the gel medium or another filler.
3 Thickly apply the paint on to the canvas. Work using a variety of colours and allow the colours to mix spontaneously.
4 Finish working on the remaining shapes using white paint. Start at the outer edge and work towards the centre where the applied colours will affect the white.
5 Add several areas of pure colour for emphasis and to bring a sense of calm to the image.

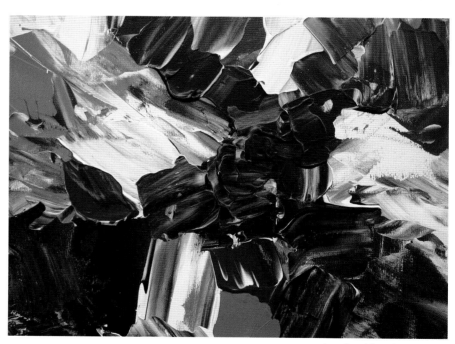

Acrylic with gel on canvas,
60 x 80cm (23½ x 31½in), A. Stuivenberg.

STUDY 7 Mixing to create 'visual language'

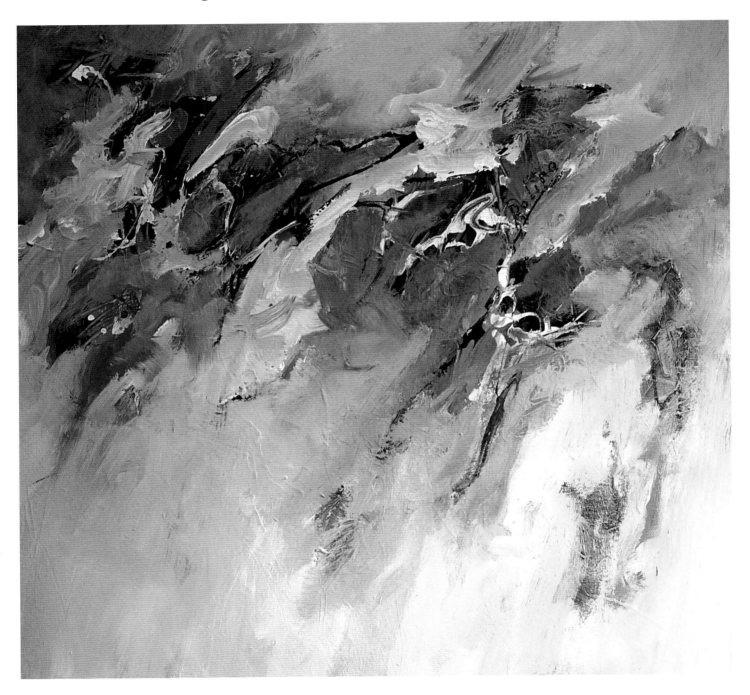

Study task
Create a work in which dynamic features are achieved by mixing.
Materials
Canvas, acrylic paint, brush.
Techniques
Apply brush and mixing techniques with the aim of allowing naturally occurring features and 'visual language' to emerge. Apply the paint with generous strokes and movement. Use the soft mixing technique when smoothing, allowing the colours to blend into each other softly. Then use a dry-brush technique, in which a small amount of paint is brushed or scratched across the focal point.
Visual elements
Line, shape, colour, tone, texture, emphasis, dynamism, variation, contrast, unity, harmony, cohesion.
Composition
Work with a composition that has a high horizontal focal point.

Work sequence
1 Start by creating a calm image on the canvas by applying large areas of colour with soft transitions. Wipe and brush the colours into each other.
2 Apply a second layer of paint to the focal point and mix using a dry brush to spread paint across the focal point.
3 Mix the contrasting colours together using several spontaneous brush strokes to create your desired visual effect.
4 Bring the colours from the active horizontal focal point to the surrounding areas, smooth and use the dry-brush method to create connections between the active centre and the passive surrounding space.
5 Finish off by adding emphasis where necessary.

Acrylic on canvas, 80 x 80cm (31½ x 31½in),
R. van Vliet.

STUDY 8 Alla prima mixing technique

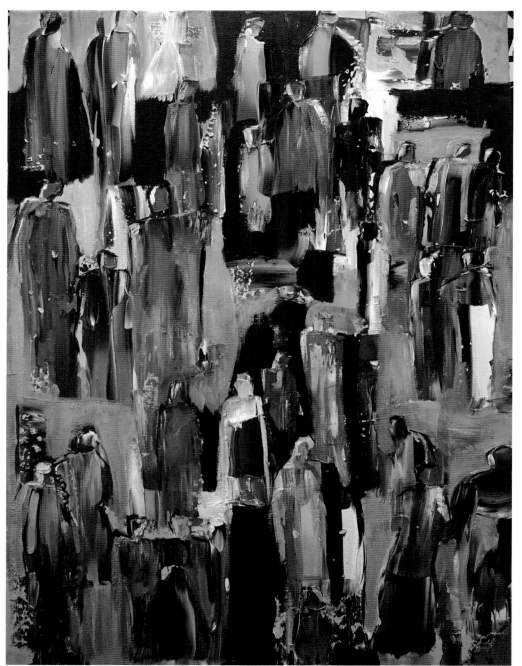

Work sequence

1 Wet-on-wet. Start with rhythmical, yellow, vertical strokes and follow with the other colours, which you should partially wipe over using the knife. Think about small features which could indicate the head and shoulders.

2 Work the remaining unpainted area using a darker, contrasting colour. In this way the shapes will separate themselves from the surrounding area.

3 Mark out contour lines in several areas using the brush and the darker colour in order to emphasise the position of the figures.

4 If you prefer, paint away areas in order to introduce space into the composition.

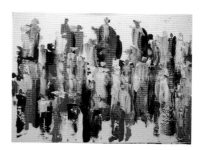

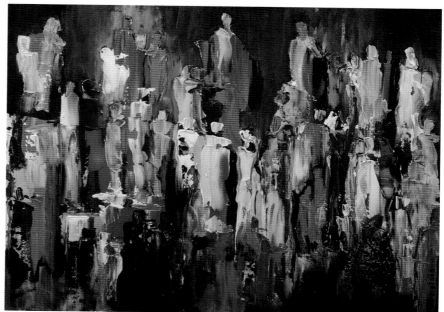

Acrylic on canvas, 60 x 80cm (23½ x 31½in), D. van Winkelhof (left and right).

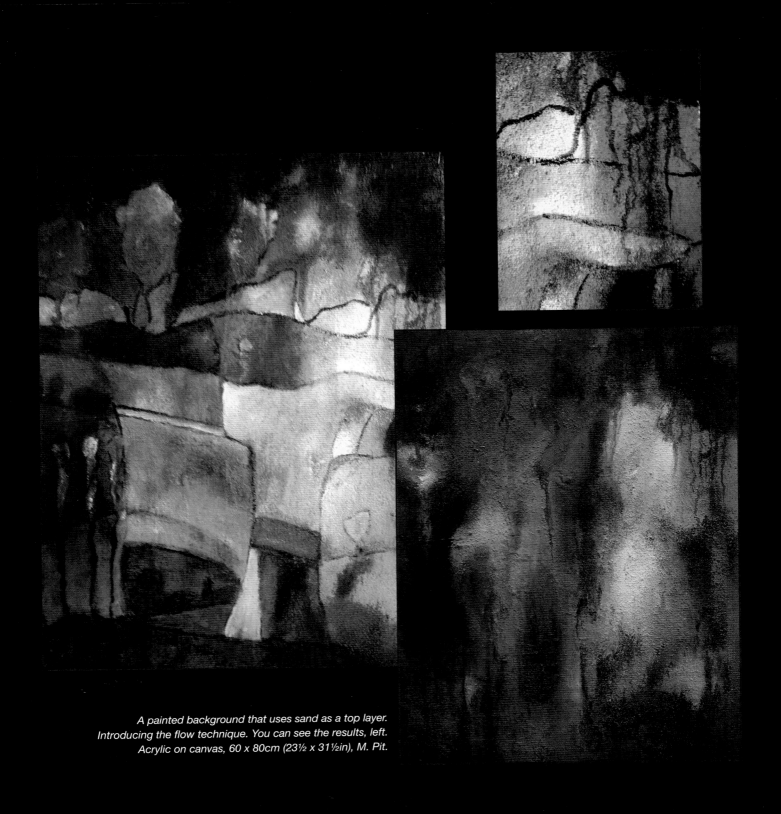

A painted background that uses sand as a top layer.
Introducing the flow technique. You can see the results, left.
Acrylic on canvas, 60 x 80cm (23½ x 31½in), M. Pit.

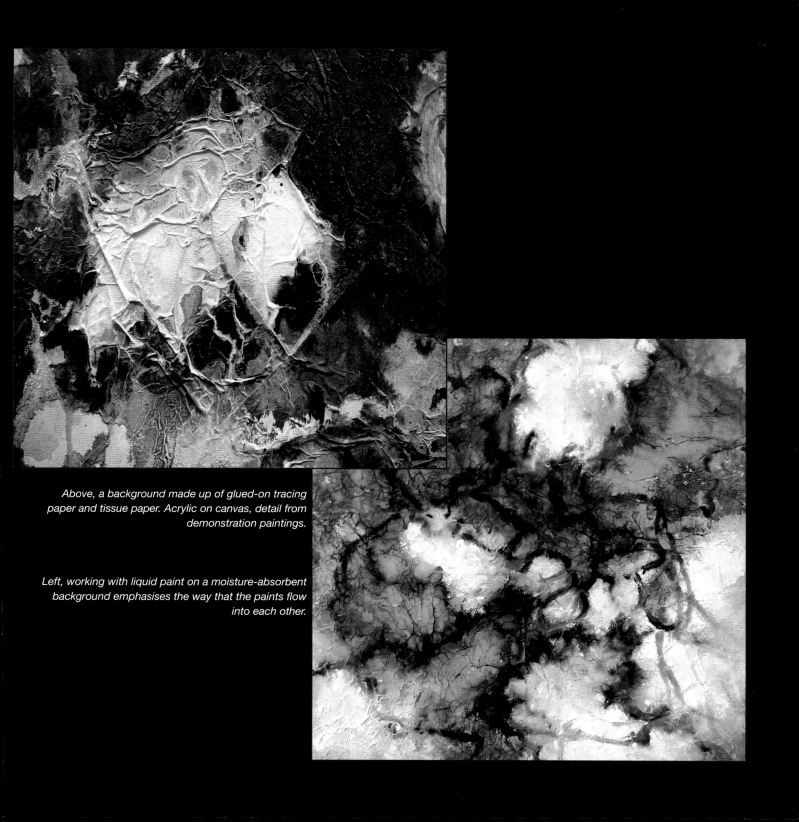

Above, a background made up of glued-on tracing paper and tissue paper. Acrylic on canvas, detail from demonstration paintings.

Left, working with liquid paint on a moisture-absorbent background emphasises the way that the paints flow into each other.

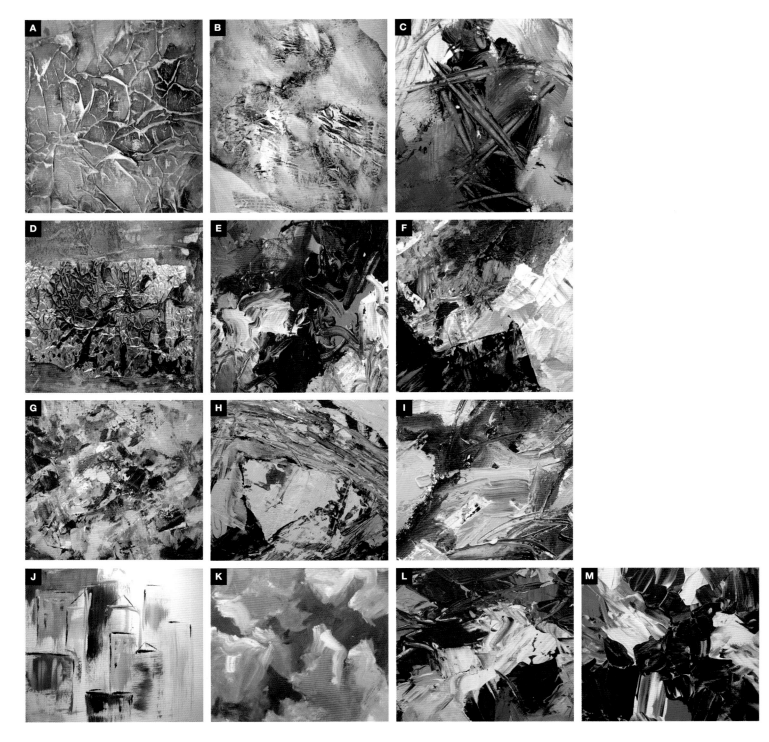

Application techniques

Since acrylic paint has the thickness and solidity of toothpaste, it is similar to oil paint. Therefore it lends itself to oil painting and impasto techniques such as the knife technique and the alla prima mixing technique and building up in layers. Above all, thick paint calls for the use of other application tools (O,P,R,V). In addition to using a brush and knife, you can also work with a foam brush, cloth, roller, rubber spatula, trowel and anything else that can be used to apply the paint.

With or without texture
Some techniques result in textures and a rich 'visual language' while the purpose of other techniques is the opposite. These techniques give a smoother and more even surface.

Using a brush:
- smooth and even, pure and graphic (Q,U,W)
- striping technique to show direction (K)
- dynamic with features in all directions (E,I)
- loose strokes, impressionistic (G)
- stencilling and dots (S,T)
- use the dry brush technique with a dry brush and a small amount of paint, wet-on-dry (A,B)
- alla prima with undiluted or thickened paint, impasto (L)
- brush strokes, vigorous brushing, wiping
- smooth by brushing the colours on the canvas into each other
- covering technique: opaque paint used to remove the background
- glazing (D).

Using a palette knife:
- scrape roughly with the side of the knife (F)
- thickly spread on the paint using thick paint and a flat knife (M)
- create long lines by using the knife length-wise (H)
- sgraffito, making score marks in the paint while it is still wet (C,X)
- stamp using the edge of the knife (J)
- mix with pure paint.

Other tools:
- sponge, foam brush or roller (J,W)
- rubber spatula, piece of wood (V,Y)
- atomiser or spray bottle (R).

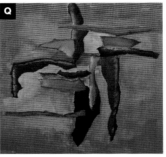

STUDY 9 Knife-scumbling technique

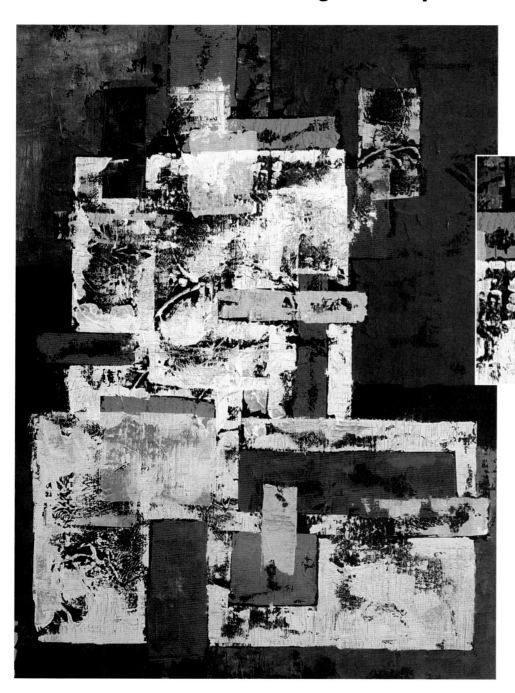

Study task
Create a study with rectangular shapes using the knife-scumbling technique.
Materials
Canvas, acrylic paint, palette knife.
Techniques
Create a rough underpainting using the knife. Paint the rectangles using the side of a palette knife with a scuffed, scraping technique. Paint the areas on top of each other and build up the painting in layers.
Visual elements
Shape, format, tone, texture, contrast, repetition, variation, equilibrium, direction, cohesion, harmony.
Composition
Sketch out a plane division with rectangular shapes in various sizes. Place the shapes on top of each other, creating depth and dimension.

Work sequence
1. Begin by introducing an underpainting. Apply the dark colour using a knife and ensure that you introduce textures and irregularities.
2. Allow the background to dry.
3. Start by introducing several large, rectangular shapes using the knife to scrape the colour on to the canvas. Since the background is uneven, the colour area you have introduced is textured.
4. Continue with other colours and introduce areas in a variety of shapes.
5. Arrange the increasingly smaller areas over each other to create depth and dimension.

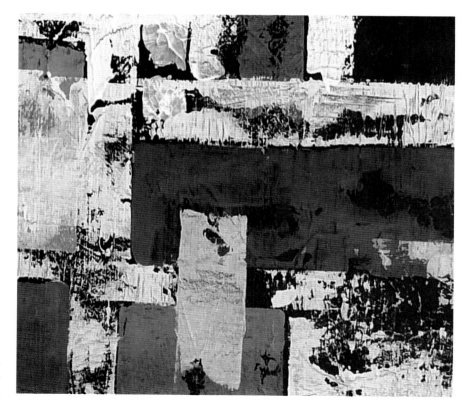

Knife technique on a textured background.
Acrylic on canvas, 60 x 80cm (23½ x 31½in),
A.Stuivenberg.

STUDY 10 Knife-and-line technique

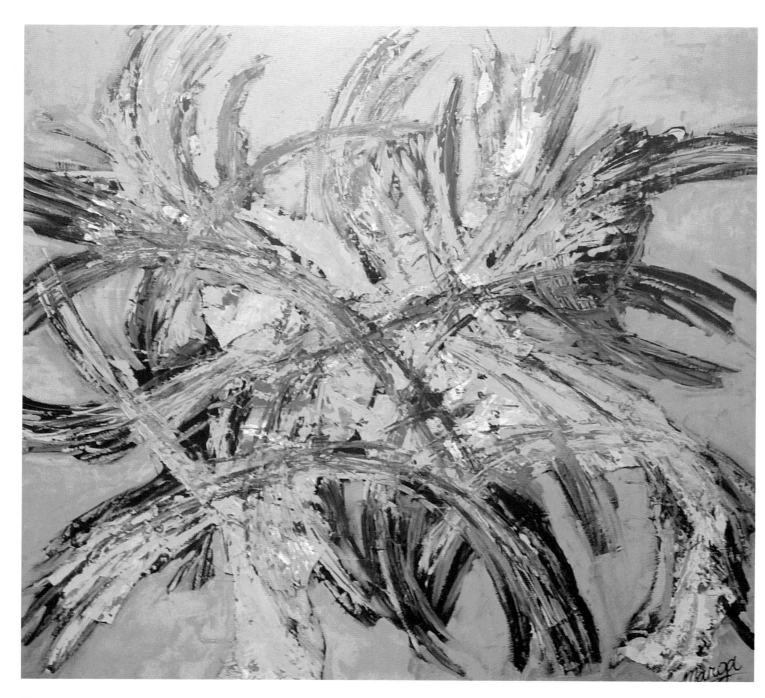

Study task

Prepare a collage material on paper using the knife-and-line technique and use this as the base to create a layered composition on canvas.

Materials

A large canvas, acrylic paint, palette knife, a large sheet of drawing paper to create the collage material, acrylic medium to attach the collage.

Techniques

Create the collage paper yourself by taking a sheet of wrapping paper and scratching and scoring long lines of paint on to the paper with the palette knife. This pattern will be the starting point for the lines and strokes that you will apply to the canvas using the palette knife. Apply a covering technique using opaque paint.

Visual elements

Line, colour, texture, tone, contrast, repetition, direction, dynamism, unity, harmony, cohesion.

Composition

Do not draw the plane division before you start. Design it instead by using torn pieces of collage paper. Introduce these around the central area.

Work sequence

1　First, create your own collage material. Use the knife to paint dynamic lines and strokes in different colours on the wrapping paper. Make sure that you can still see the colour of the paper.
2　Allow the paper to dry and tear it up into randomly sized pieces.
3　Apply a dark underpainting to your canvas.
4　Arrange a composition using the collage materials leaving a lot of free surrounding space, and attach the materials to your underpainting using the paint or acrylic medium.
5　Now set to work using the knife and the paint. Use the same colours that you can see on the collage material. Use the knife to make further large strokes on the canvas and use the lines on your collage material to determine the direction of the strokes. Do this in such a way that the surrounding area appears to be a continuation of what is on the collage material. In this way, the attached material is fully incorporated into the work and you can hardly see the paper stuck to the canvas.
6　Lastly, evenly paint the passive areas in one single colour to add calm regions to your work. While you are doing this, do not forget to cover a few areas in the centre with the surrounding colour. This has the effect of making the centre look less solid.

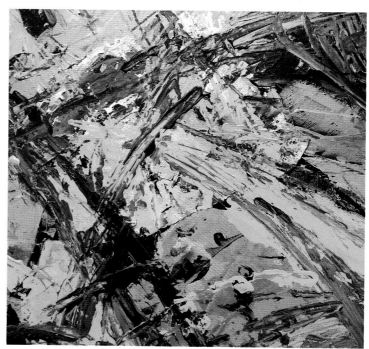

Mixed techniques. Acrylic and paper collage, integrated with the knife-and-line technique on canvas, 100 x 100cm (39½ x 39½in), M. Rabouw.

STUDY 11 Impressionist knife techniques

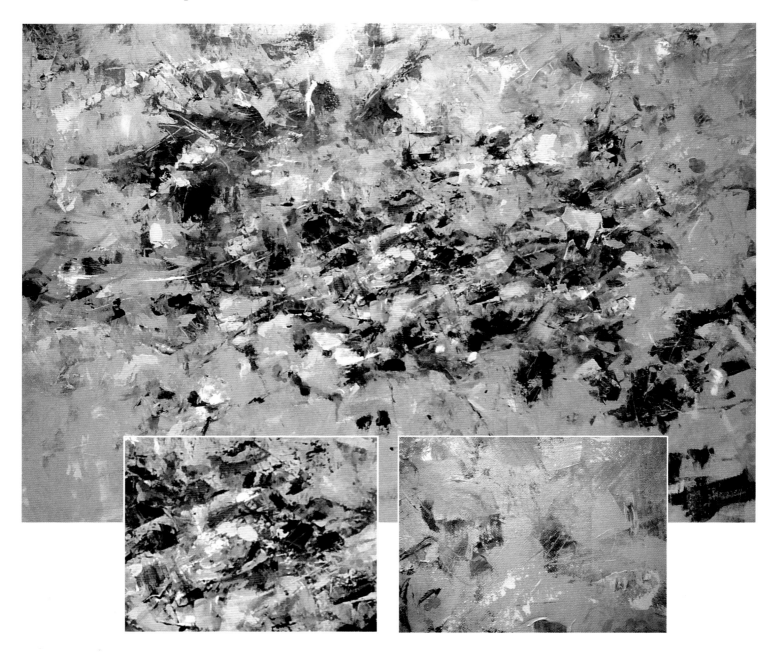

Above, 60 x 80cm (23½ x 31½in).
Theme: summer. C. van Beijeren.

Study task
Create a work with the theme: 'the summer of...' and use an appropriate knife technique.
Materials
Canvas, acrylic paint, palette knife.
Techniques
Using impressionist techniques, play with the technical possibilities of the palette knife. This time, introduce small touches of colour, avoid brushing the colours into each other too much and build up the work from light to dark. Each feature adds something to the texture and pattern that will appear on the canvas.
Visual elements
Shape, spots, colour, texture, emphasis, rhythm, repetition, pattern, unity, harmony, cohesion, movement.
Composition
Begin the work without a plane division or composition. Take the liberty to apply texture and touches of colour to the canvas in a completely instinctive way so as to create a rhythm that fills the entire canvas.

Work sequence
1 You can begin with an even underpainting and then build up the lower layer with the knife in light, pastel-coloured hues, with colour areas in all directions. Work using the wet-on-wet method, which will allow subtle mixtures to occur.
2 Apply the next layer using smaller strokes and then start to introduce some colour emphasis.
3 Continue doing this, gradually increasing the colour strength.
4 Thoroughly distribute the colours across the entire image and choose slightly higher colour concentrations for the central areas.
5 If you prefer, use the neutral base colour to brush away the excess strokes to bring in a sense of calm.

Variation
You can also use this technique to depict a figurative theme, such as a crowd of people.

Acrylic on canvas, in a fully personal and expressive knife technique.

Below, Theme: a crowd.
50 x 60cm (19¾ x 23½in), C. van Beijeren.

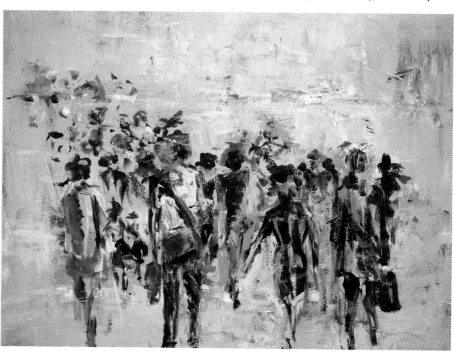

STUDY 12 Sgraffito as a 'visual language'

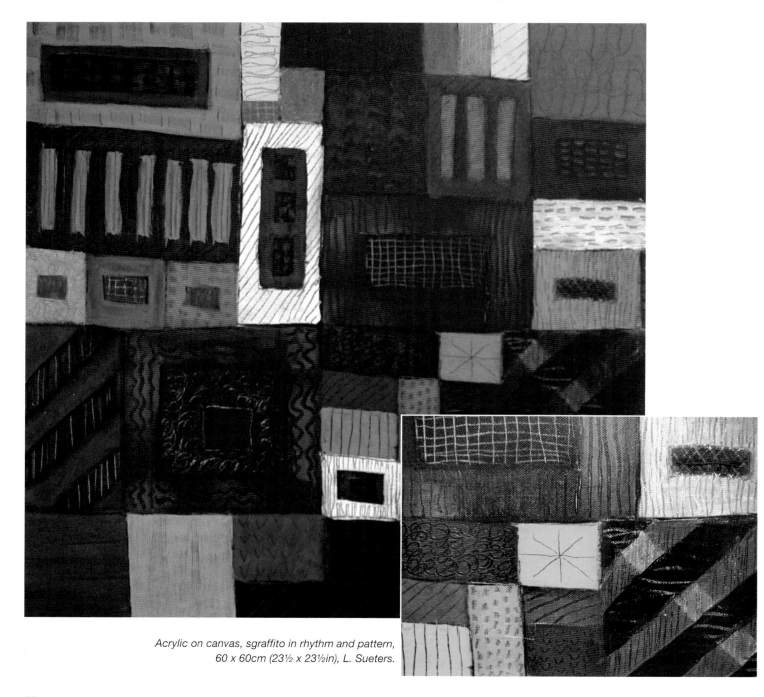

Acrylic on canvas, sgraffito in rhythm and pattern,
60 x 60cm (23½ x 23½in), L. Sueters.

Study task

Build up a work that consists only of rectangular shapes in horizontal and vertical directions and create the texture using the sgraffito technique.

Materials

Canvas, acrylic paint, flat brushes, palette knife.

Techniques

Introduce the rectangular shapes using brushes of varying widths. Apply the sgraffito technique by making score marks in the wet paint with the palette knife to introduce a variety of patterns and liven up the areas. In this way you will build up the work for each rectangular shape and only start the next rectangle when you have finished the previous one.

Visual elements

Line, shape, format, colour, tone, texture, harmony, contrast, equilibrium, cohesion, rhythm, unity.

Composition

Create the work with only rectangular shapes in horizontal/vertical equilibrium. Avoid imagining the plane division beforehand. During the painting process you will work towards a composition that fills the entire canvas with the emphasis on rhythm, repetitive shapes and shape variation.

Work sequence

1 Choose your colour palette and start, in the middle of the canvas, by introducing your first rectangular shape. Paint the inner area and introduce patterns by making score marks in the wet paint with a palette knife.

2 Gradually build up the work by placing further squares alongside these. While you do this, make sure that the following square is a different shape and has a different orientation to the previous one.

3 In this way, you will build up the work step by step. You should also vary the thickness of the diamond shape, the orientation and patterns that you introduce into the wet paint.

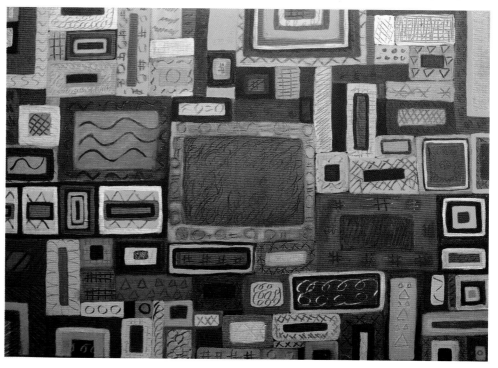

60 x 80cm (23½ x 31½in), L. Cyrus.

STUDY 13 Knife technique

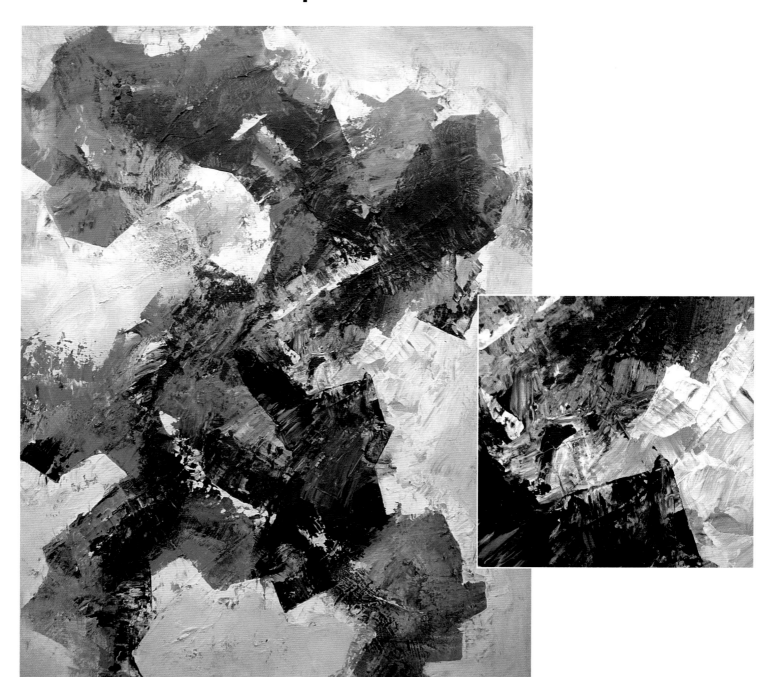

Study task

Create a study using only the palette knife.

Materials

Canvas, acrylic paint, palette knife, gel for the variation study.

Techniques

Apply the knife scumbling technique thinly scraping the paint using the side of the knife; and use a mixing technique to apply wet-on-wet, which will cause the colours to blend. For a variant, apply the alla prima mixing technique.

Visual elements

Shape, colour, tone, texture, harmony, unity, dynamism, contrast.

Composition

Design a dynamic composition that is surrounded by passive, calm shapes.

Work sequence

1. Apply a rough, dark underpainting using the palette knife. This will give the work a certain texture.
2. Freely sketch out a plane division on the canvas.
3. Apply the paint by using the knife to scrape the colour on to the canvas with angular strokes. Make sure that parts of the underpainting remain visible. Superimpose the colours, wet-on-wet, which will cause the paints to mix on the work. Use the side of the knife to show the shapes.
4. Work the surrounding space with the same technique, this time using a light colour, which will give the focus composition a clear shape.
5. Bringing the colours from the centre to regions of the surrounding space will give the work unity and cohesion.

Variation

If you prefer, mix the paint on the top layer with the structure paste or gel to thicken it. This will give greater relief to the texture. In any case, you should apply the paint less thinly and, using the alla prima mixing technique, place thick daubs of paint on to the canvas in lively strokes.

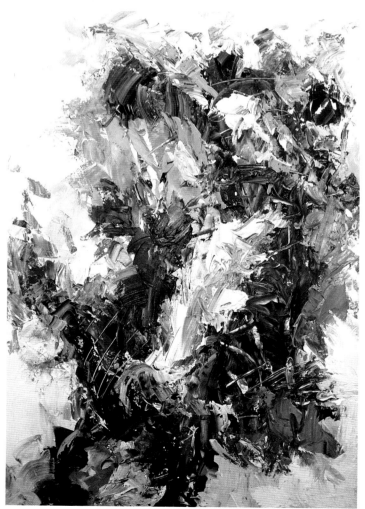

Acrylic on canvas,
60 x 80cm (23½ x 23½in),
A. Stuivenberg (left and right).

STUDY 14 Working with a foam brush

Painting shapes using a foam brush.
Acrylic on canvas, 60 x 80cm (23½ x 23½in),
A. Stuivenberg.

Study task
Create a city view theme using a foam brush and knife-scumbling technique.
Materials
Canvas, acrylic paint, foam brush or sponge.
Techniques
Work using a dry scraping motion with a dry foam brush. Take a thin layer of paint, without water, and use the brush to gently brush this over the canvas. Create rectangular shapes by using the wide side of the brush. Then use the top of this brush, employing the line-stamping technique (see p.120).
Visual elements
Line, shape, colour, tone, format, texture, rhythm, repetition, contrast, equilibrium, harmony, cohesion.
Composition
The composition is created from the rectangular shapes that you introduce across the entire canvas.

Work sequence
1 Begin by underpainting in a light colour.
2 Continue using contrasting and complementary colours. Use the foam brush to introduce scuffed, rectangular shapes on to the canvas. While doing this, overlap the shapes which will allow the colours to mix visually.
3 Use the top of the brush to add several line features to suggest the corners of buildings and roofs.
4 Finish off with several features that could suggest windows. Do not add too many detailed lines or windows. You only need to evoke the idea of a buildings.

Variation
Even without accentuating the edges, this creates an effective city image.

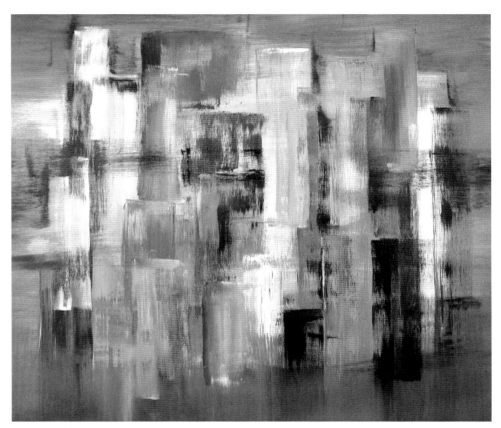
C. van Beijeren.

STUDY 15 Technique without texture

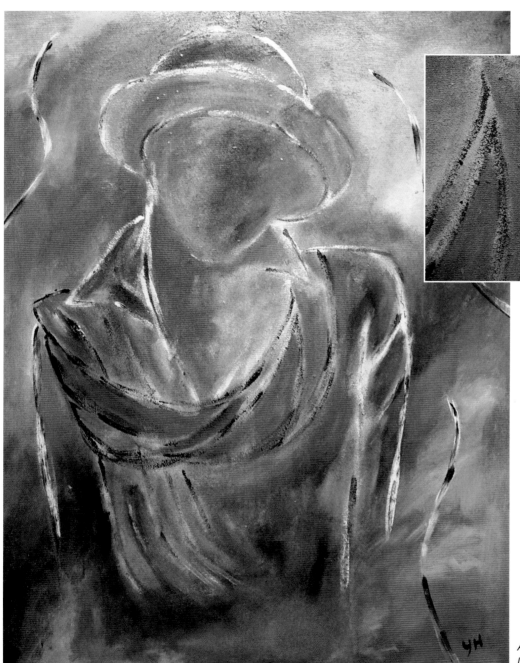

Acrylic on canvas.
Left, 60 x 80cm (23½ x 23½in), Y. van Rooijen.

Study task
Create a human figure with soft transitional colours without texture.
Materials
Canvas, acrylic paint, brush.
Techniques
Employ the mixing technique using a brush and colour transition. Blend the colours into each other on the canvas to create soft transitions. Smooth over it sufficiently so you can no longer see any brush strokes and the surface is visibly smooth. Use the line technique in which you introduce a soft contour drawing using a brush and paint. In the variant study employ a covering technique to create a negative painting for the background.
Visual elements
Line, shape, colour, tone, format, contrast, dynamism, harmony, unit, cohesion.
Composition
Place an abstracted version of a human figure, or figures, in the centre of the painting area by showing the shape in two dimensions or from alternate angles.

Work sequence
1 You can begin with an even underpainting. Allow it to dry first.
2 Then apply various colours across the entire canvas and allow them to gently run into each other.
3 Using the back of the brush, score out a contour drawing in the paint while it is still slightly moist.
4 Add extra line features in certain areas using a brush with some paint.

Variation
You may be already able to see some shapes in your work after this second stage, which give the impression of human movement. In this case, leave the outlined drawing as it is and paint around the shapes with opaque paint. By using this covering technique, the shape will seem to emerge from out of the background. This is a type of negative painting for making the positive shape visible.

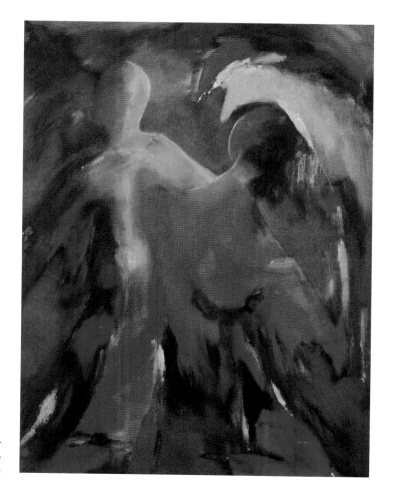

Theme: human form in profile.
Right, acrylic on canvas, 50 x 65cm (19¾ x 25½in),
R. Eelsing.

STUDY 16 Dynamic painting techniques

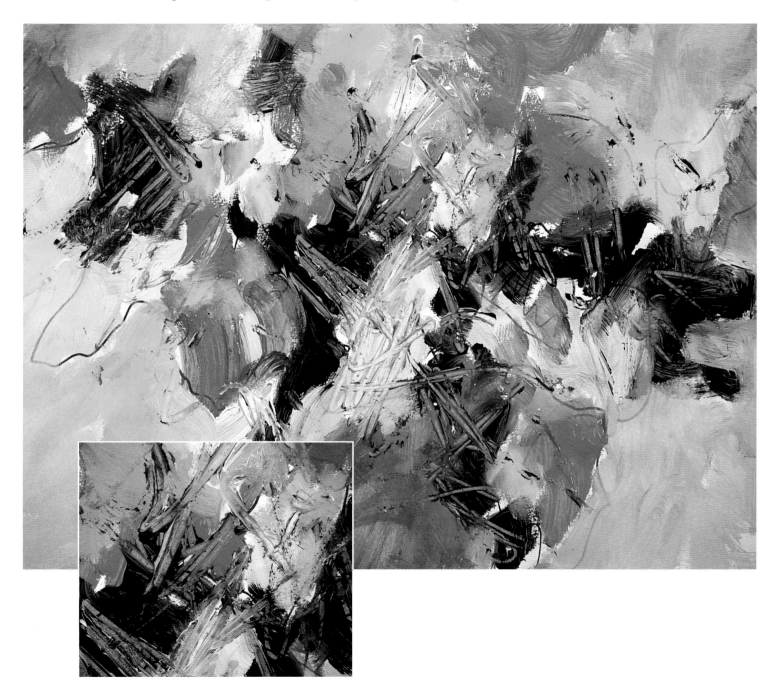

Study task
Construct you work with quick and dynamic brushstrokes.
Materials
Paper or canvas, acrylic paint, brush and/or palette knife.
Techniques
Build up the colours using the wet-on-wet method. Do not brush through the paint too much; the dynamism of the brush stroke is often interesting in itself. Use the tip of the brush, or a palette knife, to make score marks in the paint, which will create unity and connections between the colour fields. Give the surrounding space a smoother and more even surface by brushing the colours into each other to make them more uniform.
Visual elements
Line, shape, colour, tone, texture, contrast, harmony, unity, dynamism.
Composition
Do not create a composition before you start, instead, begin in the centre and work outwards to the edges.

Work sequence
1 Begin in the centre of the canvas by applying the lightest colour and then continue with the other colours.
2 Add a second ring of colour and mix this with the first layer that is still wet.
3 Once you have sufficient features and colour variation, make score marks in the wet paint to create connections.
4 Finish the painting by bringing the colours to the edges, then use the brush to blend the colours into each other until the mixture is even and there is no texture.

Tip
When you paint using the wet-on-wet technique, choose colours that combine well, such as an analogue or monochrome colour scheme.

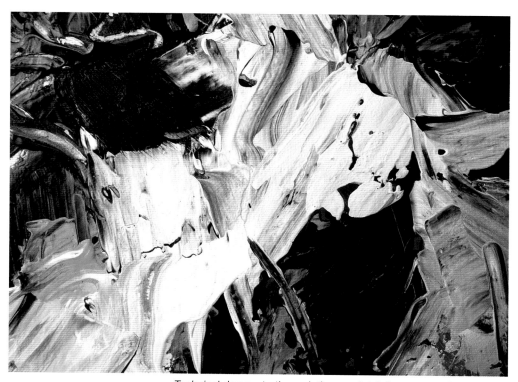

Technical demonstration paintings and details on paper, R. van Vliet.

69

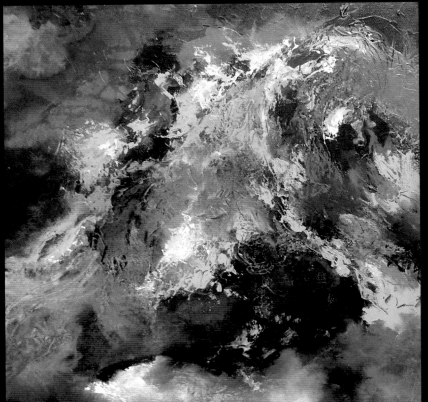

You can apply paint and mix it using the various techniques.

Left, alla prima with palette knife and brush.
Acrylic on canvas, 50 x 50cm (19¾ x 19¾in), A. Verhagen.

Below, paint with sand texture and the flow technique.
Acrylic on canvas, 50 x 120 cm (19¾ x 47¼in), A. Verhagen.

Right, mixing using a dynamic brush stroke and texture with a rubber spatula.
Acrylic on canvas, 70 x 70 cm (27½ x 27½in), R. van Vliet.

Below right, soft and even colour fields blended with a brush.
Acrylic on canvas, 60 x 70 cm (23½ x 27½in), A. Klein Gotink.

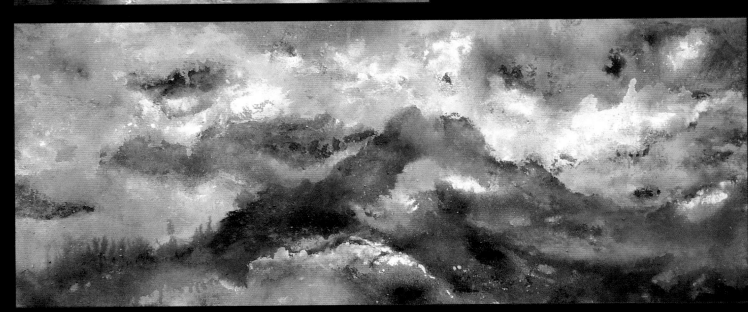

Additions, relief and background techniques

You can add fillers to the paint while it is still wet that will make it thicker and give a relief effect on the paper. For instance, you can use sand, sawdust, paper, plaster of Paris, cement paint, cardboard, rope, wool or textiles. The thick consistency of the paint will absorb nearly anything, without any difficulty. In addition to using home, garden and kitchen materials to fill your paint, you can also experiment with acrylic mediums, modelling pastes and special gels that are available for this purpose. This enables you to introduce texture to both the background and the painting itself.

You can choose from:
- gesso or paint, applied roughly using a knife (D)
- creating shapes using gel or texture paste (C)
- French chalk powder or plaster of Paris as a filler (J,L)
- scored lines in the wet lower layer (H)
- textured wall paint, such as artex (A,I)
- paint or gesso containing sand or with sand sprinkled on top (B)
- smooth or crumpled newspaper or paper underneath or on top
- smooth or crumpled tracing paper placed below or on top (G)
- aluminium foil (E)
- sandpaper (F)
- sawdust (K).

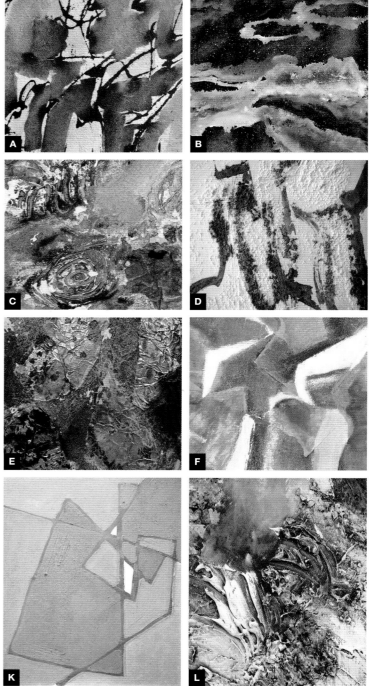

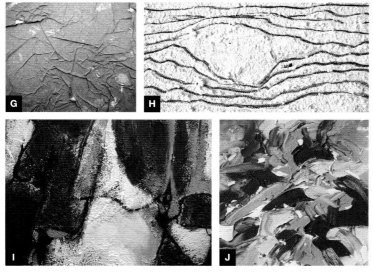

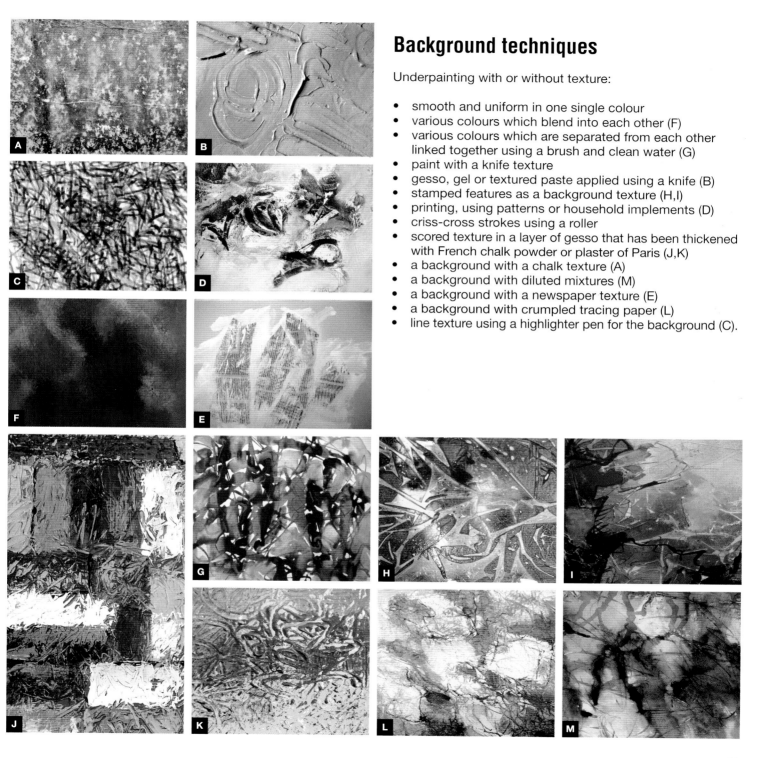

Background techniques

Underpainting with or without texture:

- smooth and uniform in one single colour
- various colours which blend into each other (F)
- various colours which are separated from each other linked together using a brush and clean water (G)
- paint with a knife texture
- gesso, gel or textured paste applied using a knife (B)
- stamped features as a background texture (H,I)
- printing, using patterns or household implements (D)
- criss-cross strokes using a roller
- scored texture in a layer of gesso that has been thickened with French chalk powder or plaster of Paris (J,K)
- a background with a chalk texture (A)
- a background with diluted mixtures (M)
- a background with a newspaper texture (E)
- a background with crumpled tracing paper (L)
- line texture using a highlighter pen for the background (C).

Study 17 Texture using French chalk powder

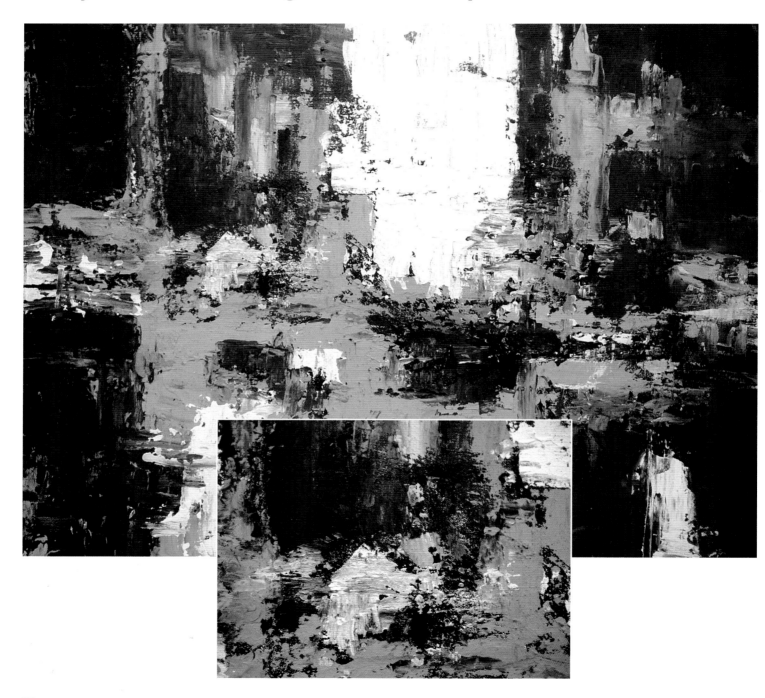

Study task
Create a layered work with texture and 'filled' paint (i.e. acrylic mixed with French chalk powder).
Materials
Canvas, acrylic paint, French chalk powder, palette knife.
Techniques
Use the alla prima and knife technique. Before starting, thicken the paint with French chalk powder.
Visual elements
Shape, colour, tone, format, texture, unity, harmony, contrast, balance.
Composition
Create a composition with rectangular shapes that fill the entire canvas. You can create the work without sketching it in advance, however, it will help if you draw similar plane divisions on a piece of scrap paper.

Work sequence

1 Begin with a dark underpainting.

2 Mix the French chalk powder into the paint that you will use. This will thicken the paint and give it a relief texture effect.

3 Apply the paint in layers using a sturdy palette knife. Blend the paint by making score marks. Start with dark hues and then work over these in lighter colours and then white. Work using the wet-on-wet method that will allow subtle mixtures to occur. Ensure that areas of the underpainting and layers below remain visible and interact with the entire image.

4 Leave the work to dry and, if you wish, add a few more vivid, light emphasis features.

Acrylic on canvas, 70 x 90cm (27½ x 35½in), I. Odenkirchen.

STUDY 18 Scored line relief effect

Right, J. Zweijtzer.

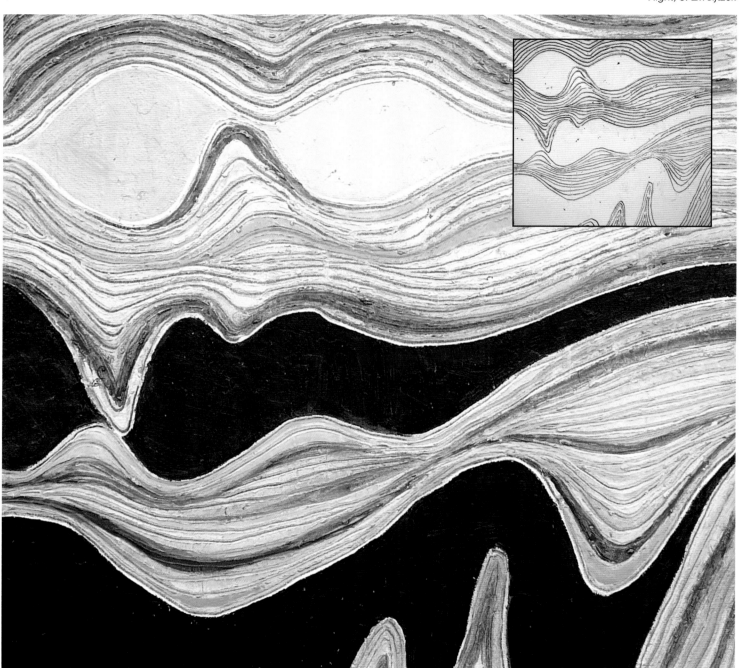

Study task
Create a work using the relief technique with a scored line rhythm.

Materials
Canvas, acrylic paint, palette knife, brush.

Techniques
Apply the relief technique. First thicken the white paint by mixing with texture medium, gel or French chalk powder. Apply a layer on to the canvas using a palette knife and use the knife to create deep score lines in the paint. Use liquid paint to introduce colour.

Visual elements
Line, shape, colour, tone, rhythm, repetition, unity, harmony, equilibrium, variation.

Composition
Design a closed, superimposed line rhythm that moves horizontally or vertically across the canvas in straight or wavy lines. As you do this, skip over several areas, which will cause shapes to emerge.

Work sequence
1 Design a clear composition.
2 Apply the filled paint mixture and score lines into it before it dries.
3 Leave it to dry thoroughly.
4 Apply colour to the entire area using liquid paint.
5 If you wish, apply paint once again to intensify the colour depth.

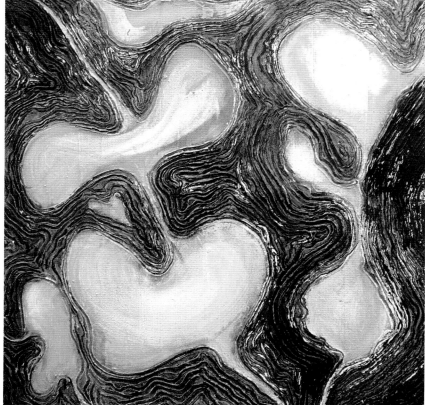

Acrylic on canvas,
40 x 40cm (15¾ x 15¾in), P. Allart.

STUDY 19 Relief technique

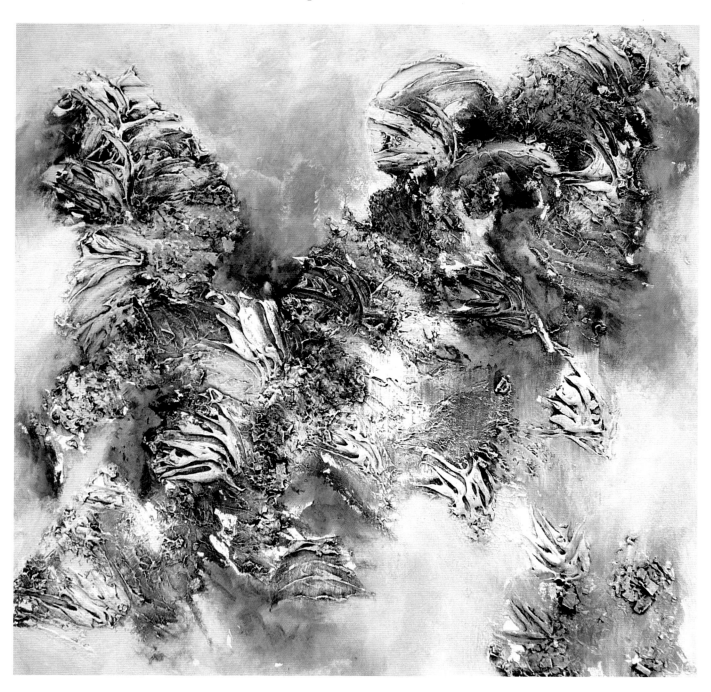

Study task

Create a work that has thick and expressive relief features.

Materials

Acrylic paint; filler to thicken the paint such as modelling paste or French chalk powder, palette knife or trowel, brush, canvas or a hard surface such as a medium-density fibreboard (MDF).

Techniques

Apply the relief technique using a palette knife to apply thickened paint to the work so that the paint-and-paste mixture covers the background and sticks out from the canvas with a three-dimensional texture. Use a dry-brush technique with dry paint to paint over the applied texture so that the background colour and texture continue to be visible.

Visual elements

Shape, tone, colour, texture, dynamism, variation, unity, emphasis, contrast, harmony, cohesion.

Composition

Design a composition with free shapes working diagonally. Leave some areas free to bring a sense of calm to the image.

Work sequence

1 Sketch your composition on to the canvas.
2 Mix the texture paste into the paint.
3 Use a sturdy palette knife to apply the thick paste on to the canvas and give it shape.
4 Work the surrounding area using a brush and water. Always take something from the texture paste, which will also bring the colours to the surrounding areas.
5 Allow all of the paint to dry and the relief paste to harden.
6 Now use the dry-brush method to paint over the texture and surrounding area so that the underlying texture is clearly visible. Use a dry brush and dry paint to softly apply brush strokes over the relief layer in a contrasting colour.
7 If you wish, use paint and a brush to bring back regions of colour to the work.

Tip

Work from dark to light or from light to dark in order to make the underlying texture clearly visible.

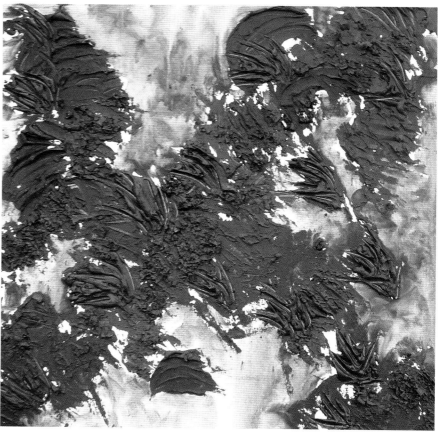

The initial design.
Acrylic and filler on canvas, 100 x 100cm (39½ x 39½in), D. Engelsman.

Left, acrylic and filler on canvas.
The final stage of the design,
100 x 100cm (39½ x 39½in), D. Engelsman.

STUDY 20 Textured background

Study task

Start a work that has partially textured spots on the background.

Materials

Canvas, acrylic paint, gesso, sand, brush, palette knife.

Techniques

Apply a texture technique in which you create separate shapes using gesso on to the background and then sprinkle with sand. Next, use the glazing technique with liquid paint, then the dry-brush technique with a dry brush and undiluted paint. Additionally, if you wish, apply the line-stamping technique with the knife for emphasis and smooth the surrounding colour areas.

Visual elements

Shape, colour, line, texture, tone, format, unity, contrast, emphasis, harmony.

Composition

Design a composition with the theme 'abstracting human forms'.

Work sequence

1 Create the background. Apply a number of free strokes to the canvas using gesso or white paint and sprinkle with fine sand.
2 Allow everything to dry thoroughly.
3 Sketch the shape composition on the canvas using charcoal.
4 Apply an initial layer of colour using watery paint and mix on the canvas. Allow the paint to drip freely.
5 Then use pure paint and the dry-brush technique to apply the paint on to a second layer. Next, apply several areas of opaque paint.
6 Add emphasis using a line-stamping effect with the side of the knife.
7 Smooth the surrounding area to create a sense of calm by brushing off the texture and covering with pure paint.

Acrylic, gesso and sand on canvas,
60 x 80cm (23½ x 23½in), J. Zweijtzer.

STUDY 21 Gel texture

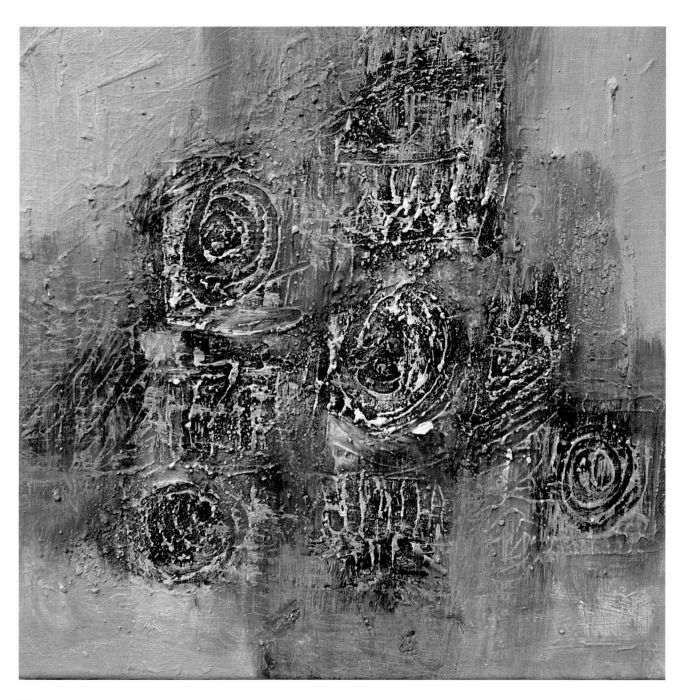

Study task
Create a work in which shapes and features are introduced in a layer of gel creating rich texture and effect.
Materials
Canvas, heavy gel medium, palette knife, acrylic paint, brush.
Techniques
Introduce relief effect textures in the gel, glazing and dry-brush method.
Visual elements
Line, shape, colour, texture, contrast, repetition, unity, harmony, equilibrium, cohesion.
Composition
Design a composition with a central focal point. Allow the features to extend to the edges and leave the corners free as surrounding space.

Work sequence
1 Apply a layer of gel to the centre of the canvas and use it to form and shape features.
2 Allow the relief-effect gel to dry thoroughly.
3 Apply a glaze to the entire canvas with acrylic paint. You will be able to see the effects of the gel shapes easily.
4 Continue to paint with pure paint to add shades.
5 Use the dry-brush method to apply white paint to the peaks of the relief areas.

Demonstration painting.
Acrylic on canvas, 30 x 30cm (11¾ x 11¾in), R. van Vliet.

STUDY 22 Using newspaper as a background

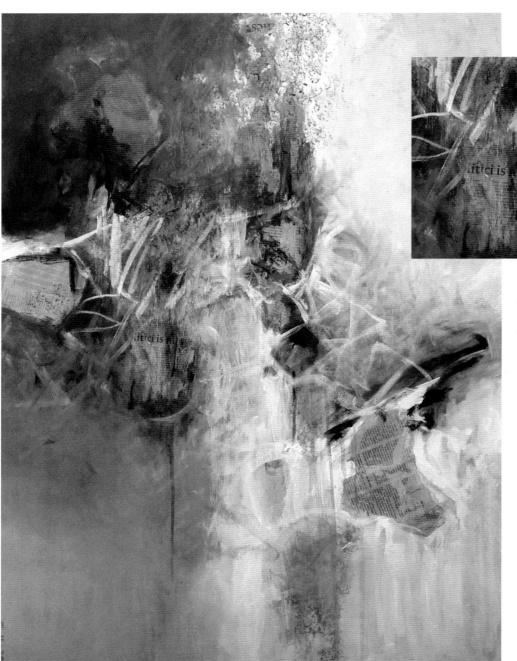

Mixed techniques.
Acrylic and newspaper as texture in the
background, 60 x 80cm (23½ x 31½in),
A. Klein Gotink.

Study task
Create a free work using newspaper in the background.
Materials
Canvas, acrylic paint, sheets of black-and-white newspaper with textual rhythm, acrylic medium.
Techniques
Create a collage made from pieces of torn newspaper. Employ glaze, line, drip and shading, smoothing and covering techniques.
Visual elements
Line, shape, colour, format, tone, texture, emphasis, unity, dynamism, direction, cohesion, harmony.
Composition
Use torn pieces of newspaper to design a shape composition with a central diagonal focus.

Work sequence
1 Stick the torn-up pieces of newspaper on to the canvas using acrylic medium. Bear in mind that the shapes should be different sizes.
2 Leave to dry.
3 Apply a glaze to the shapes.
4 Paint the surrounding area and allow the hues to blend together and the surface to become smooth.
5 Re-apply the glaze to some areas and allow droplets to run freely across the work.
6 For additional effect, score or stamp emphasis lines in the central area.

Variation
You can also use pictures from newspapers as the background for visual effect. Scrape the knife over several parts of the background. Paint in a few calm, passive areas using the covering technique with opaque paint.

50 x70cm (19¾ x 27½in), C van Beijeren.

85

STUDY 23 Paper texture

Study task
Create a work that uses crumpled paper as the basic texture in the lower layer.
Materials
Canvas, acrylic paint, palette knife, thin paper or tracing paper.
Techniques
Make use of a textured background made from paper. Stick the paper on to the canvas using acrylic medium or gel and pinch it in certain areas to create creases. Use a dry-brush and glaze technique to apply colour.
Visual elements
Line, shape, colour, tone, texture, contrast, harmony, unity, cohesion.
Composition
Design a line composition with a central focal point and some free surrounding space.

Work sequence

1 Stick the paper to the canvas, spread the texture of the paper's creases across the canvas and leave the work to dry.
2 Sketch the line composition on to the canvas. Apply the main colours using a brush and shade the colours into one another.
3 Determine the light tone features and apply.
4 Emphasise the line interplay, which will strengthen the contrast and composition.

Variation
Create a second work in a totally different composition and colour combination, but using the same background as the texture.

Acrylic on canvas,
60 x 60cm (23½ x 23½in),
P. Wiekmeijer
(left and right).

STUDY 24 Sand texture

Acrylic on canvas using sand and the flow technique,
80 x 100cm (31½ x 39½in),
J. van den Borden.

Study task

Abstract and develop a landscape composition using a sand texture background.

Materials

Canvas, sand, acrylic paint, brush.

Techniques

Apply the flow technique. Work with watery paint on top of a background with a sand texture. The sand texture will absorb the paint, which may cause the colours of the watery paint to flow into each other, as if it were watercolour paint.

Visual elements

Line, shape, colour, texture, format, tone, harmony, repetition, unity.

Composition

Design a landscape composition that only has a handful of main lines. Superimpose a second composition that is made up of horizontal and vertical lines (a grid composition). This composition will break up the landscape image so that, together with the later colour division, it will be more reminiscent of a rhythm of shapes, colours and stripes than a landscape.

Work sequence

1 Apply the desired texture to the lower layer covering the canvas with a layer of white or coloured paint. Sprinkle sand into the paint while it is still wet.
2 Allow everything to dry thoroughly.
3 Use charcoal or chalk to outline the dual, grid composition on the canvas.
4 Now add emphasis to the lines with slightly wet paint.
5 Fill the remaining space using watery paint. Bring together various colours to create flowing colour mixtures and transitions.

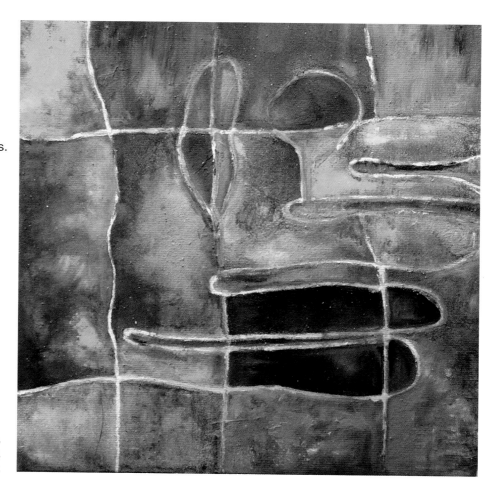

Acrylic on canvas using sand and the flow technique,
100 x 100cm (39½ x 39½in),
C. Goedvolk.

*Right, a graphic work
with colour transition
in the colour fields and
masked-out lines,
60 x 80cm
(23½ x 31½in),
M. Pit.*

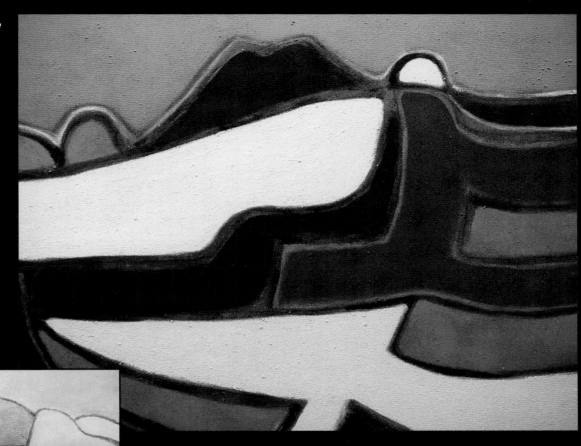

Theme: abstracting a landscape
Technique: flow technique on
a background of acrylic paint
and sand.

Above, a graphic, rigid work with even,
uniformly coloured areas and wide contour
lines, 60 x 80cm (23½ x 31½in), P. Allart.

Collage, integration and print-and-stamp techniques

Acrylic paint is highly adhesive and can be applied to almost any background. Since the paint dries as a nonporous layer, it is also good for attaching all manner of other materials. This makes it the ideal adhesive and suitable for creating collages, for example with:

- paper: uniform, neutral, coloured, patterned, newspapers, from magazines, rice paper, tracing paper, cardboard, corrugated card, pictures and photos (B,C,F,I).
- textiles: ranging from smooth and neutral to sackcloth, netting or rope (A,D) and coloured textiles with patterns.
- found objects: objects which are interesting to use for their 'visual language' because of their shape, colour or texture.
- natural materials: slate, leaves, reed, etc. (E,G).

Integration technique

When you use collage materials it is important to incorporate them as much as possible into the painting in such a way that you can barely see that the parts have been stuck on. Above all, our task here is to incorporate the collage areas and the remainder of the painting into one cohesive whole. We can encourage incorporation by doing the following:

- applying thick paint over the glued edges (H)
- applying a printed pattern over the collage and its surroundings (I)
- moving the colour of the collage parts towards the surrounding colour (J)
- applying glaze layers
- using the dry-brush technique with watery paint over the collage and its immediate surrounding areas (K)
- applying stripes and brush strokes using paint and knife (F).

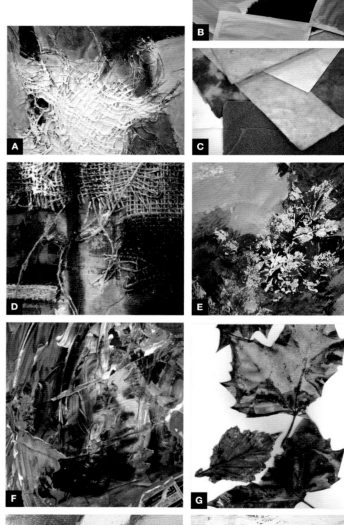

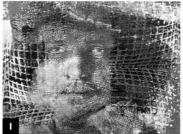

rint-and-stamp techniques

crylic paint is highly suited for making prints. Print
echniques such as the mono-printing and stamp-and-
tencil techniques are practical tools to enhance the
'isual language' of the abstract painter. For instance, we
an employ printing techniques by using:

- relief wallpaper print as integration and unity (B,H,I,J)
- structured work using pattern stamps (E)
- stamps, which you can even make yourself
- household implements as a stamp
- mono-printing (K)
- a sponge or ball of paper
- packing film as the background or on top of the work as a feature (D)
- leaves or other shapes from nature (C)
- a stipple effect on templates (A)
- cling-film printing (F,G).

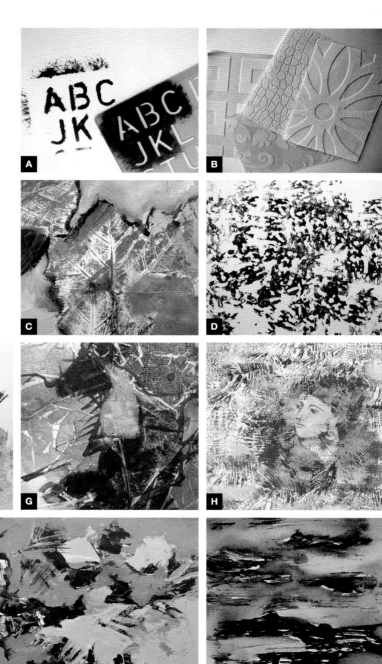

STUDY 25 Textile texture

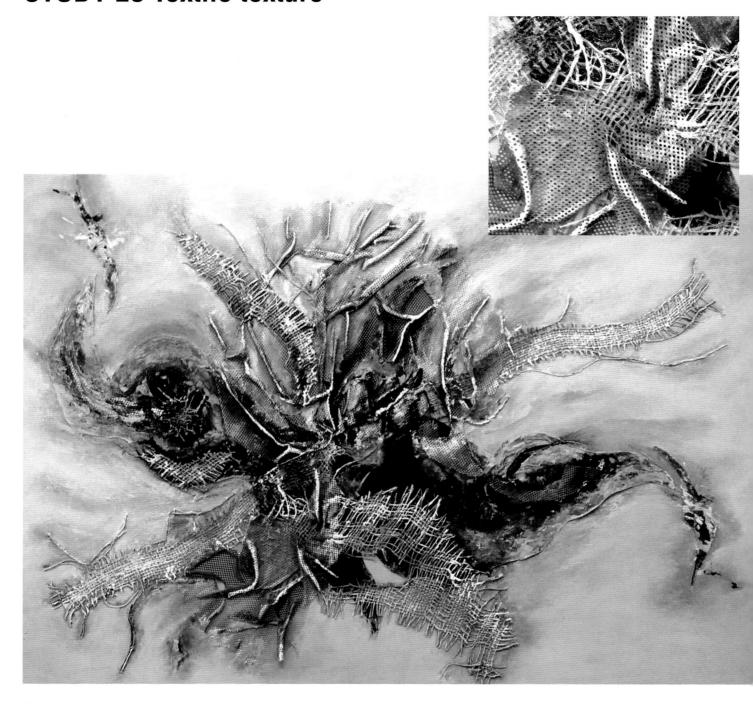

Study task
Compose a work using textiles as the distinctive texture.
Materials
Canvas, acrylic paint, gel medium (or another type of strong, transparent adhesive), brush, various types of textiles with different structures and patterns in neutral hues.
Techniques
Apply the collage technique to attach the material. Use the integration technique to bind the material and the remaining shape into one whole. Do not just use the collage materials as they are, but work them into an interesting shape and texture by tearing, pulling out threads or cutting them open. In short, add your own touches to these materials. Use a covering and smoothing technique for the surrounding colours.
Visual elements
Shape, line, texture, colour, contrast, emphasis, dynamism, variation, unity, direction, harmony, cohesion.
Composition
Arrange a radial composition from the centre of the canvas using textiles. Choose a variety of textures for this.

Work sequence
1 If you wish, start with an underpainting and allow it to dry.
2 Arrange the textile parts and attach to the canvas using strong glue or gel and leave the work to harden.
3 Use the incorporation technique, in which the textile parts and the surrounding space are connected to each other becoming one whole. You should use pure, thick paint to bind the textile parts to the remaining space.
4 Smooth the area around the textile parts with pure paint and create soft mixtures to bring calm to the whole work.

Tip
Always ensure that the parts you have stuck on are properly attached so that they form a thick top layer there should be no loose hanging parts that might make the work delicate.

Mixed techniques using textile collage on canvas,
60 x 80cm (23½ x 31½in), A. Verhagen.

STUDY 26 'Painting' with coloured paper and pastels

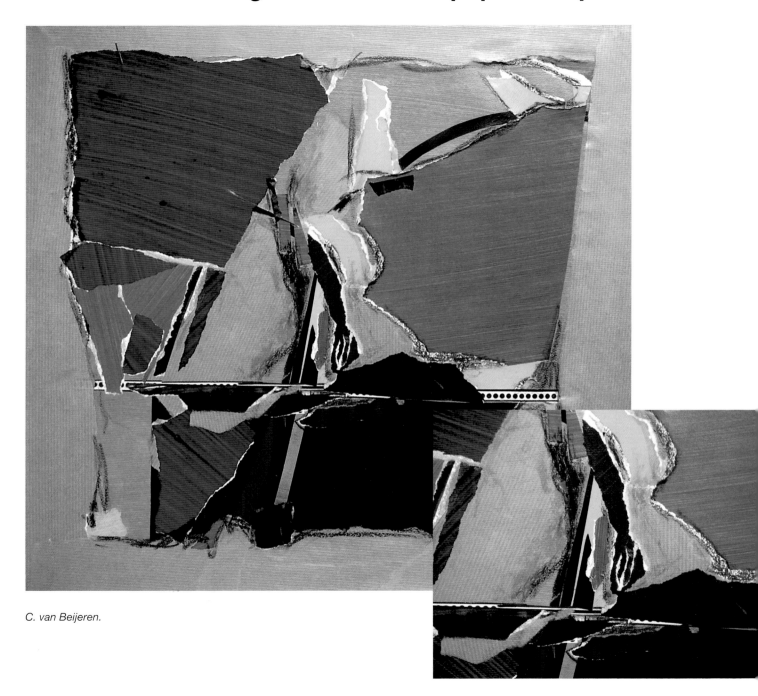

C. van Beijeren.

Study task
Build up a work using coloured paper and pastel crayons without the use of paint.

Materials
Canvas, acrylic medium (or another transparent adhesive), paper you have coloured, wrapping paper, oil pastel crayons.

Techniques
Apply the collage technique to stick on pieces of paper, and the pastel technique to introduce emphasis and connections.

Visual elements
Line, shape, colour, tone, format, texture, emphasis, contrast, equilibrium, harmony, cohesion.

Composition
Distribute the various colours and textures evenly across the canvas, filling the entire area with materials.
You can also paint a border around the canvas which looks like a frame.

Theme variation: painting with paper and oil pastel crayons. Mixed techniques.
Acrylic on canvas, 30 x 30cm (11¾ x 11¾in).
Two studies by P. Allart.

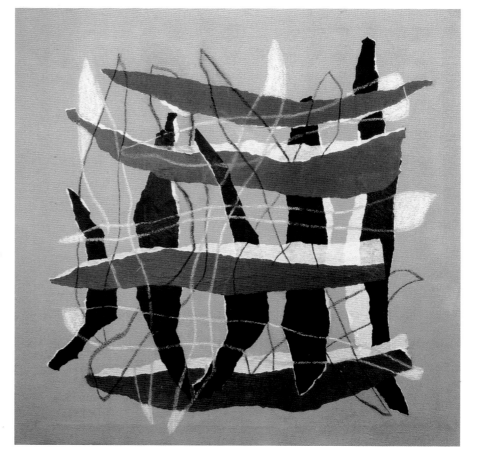

Work sequence
1. Prepare the coloured paper.
2. Cut or tear it into pieces of varying sizes.
3. Arrange everything on the canvas so that it is evenly distributed and attach.
4. Stick on small paper features over the first layer to make use of size, emphasis, contrast and variation.
5. Use oil pastel crayons to introduce lines and textures and create unity and cohesion.

STUDY 27 Collage using slate

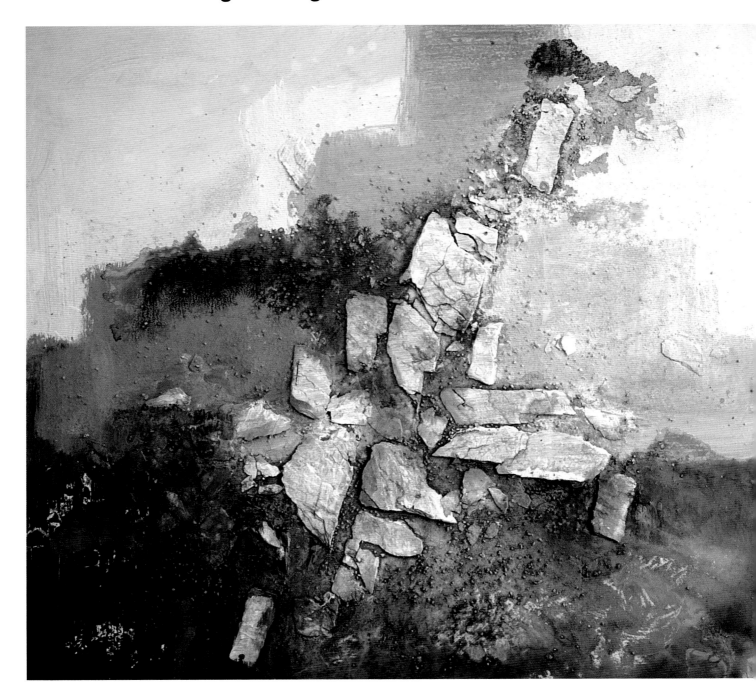

Study task
Use materials taken from nature and incorporate them into your work.
Materials
MDF panel, acrylic paint, pieces of slate, glass beads, brush, heavy gel.
Techniques
Apply a collage technique in which pieces of slate are attached firmly. Use the flow-painting technique and smooth out surrounding colour areas.
Visual elements
Shape, colour, tone, texture, format, harmony, variation, unity, contrast, emphasis, direction, cohesion.
Composition
Design a cross-shaped composition with a central focal point and surround with calm, passive space.

Experimental study.
Acrylic and slate
on MDF board,
60 x 60cm (23½ x 23½in),
R. van Vliet.

Work sequence
1 Use pieces of slate to create the composition and stick them on to the hard background (MDF panel) using heavy gel or another powerful adhesive.
2 Allow the work to dry thoroughly.
3 Continue by painting the surface with white paint and sprinkle fine glass beads on to the surface for texture.
4 Apply colour to the entire area using several coats of liquid paint.
5 Apply more uniform areas of colour to the surrounding space using opaque paint.

STUDY 28 Printing technique as integration

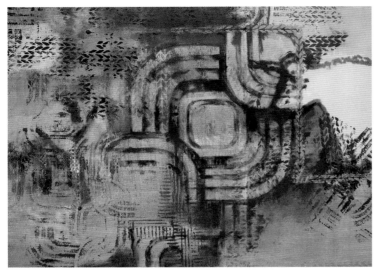

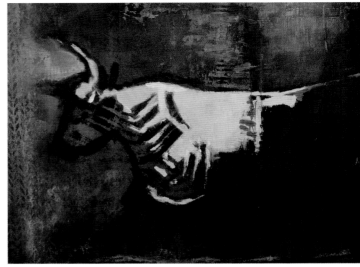

Acrylic and paper on canvas, 50 x 120cm (19¾ x 47¼in), A. Klein Gotink.

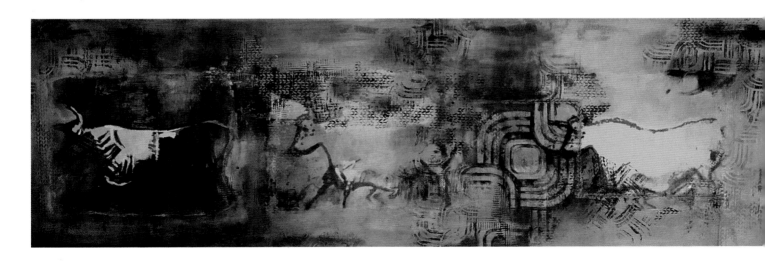

Study task
Create a work in which printed images are elaborated and integrated using a variety of techniques.
Materials
Canvas, acrylic paint, copy of rock drawing images, embossed patterned wallpaper or stamps, brush, acrylic medium.
Techniques
Collage technique using black-and-white copies of images. Integration technique using painting and the printing technique with embossed patterned wallpaper or stamps. Follow this with a wash or glazing technique.
Visual elements
Line, shape, colour, tone, texture, rhythm, repetition, pattern, unity, cohesion, emphasis, contrast.
Composition
The images you have selected determine how the image plane is balanced.

Work sequence
1 Select the images you will use and distribute them across your picture.
2 Attach these to the canvas using acrylic medium and allow to dry thoroughly.
3 Apply an initial layer of colour by washing or glazing with watery paint.
4 Apply opaque paint in several areas to smooth away the edges of the stuck-down paper and incorporate these into the entire composition.
5 Further incorporate the images by applying a pattern print to the images and the surrounding area. Use embossed patterned wallpaper or stamps for this.
6 Use opaque paint to finish off the work and reinforce the shape, contrast and cohesion.

Acrylic paper on canvas, 30 x 80 cm (11¾ x 31½in), J. Zweijtzer.

STUDY 29 Using letters as texture

Study task
Create a work using letter textures as the 'visual language' of the piece.

Materials
Canvas, acrylic paint, brush, collage materials with letter print, newspaper, acrylic medium.

Techniques
Create your own collage materials using type fonts on a computer and stick the parts on to the canvas. Follow this with the drip technique, glaze and smooth using opaque paint.

Visual elements
Line, texture, rhythm, tone, contrast, pattern, dynamism, equilibrium, direction, harmony, cohesion.

Composition
Begin the composition with the placement of the collage elements in the centre of the canvas and develop it further through the painting process. The flow of the watery paint establishes the direction.

Work sequence
1. Use your computer to create your own letter patterns. Use unreadable symbols and individual characters, not words, in various fonts, thicknesses and sizes. Add the newsprint from the newspaper to complement this.
2. Cut or tear the prints into pieces and distribute them across the canvas. Attach the prints using acrylic medium.
3. Apply a glaze to areas of the print and the background.
4. Continue with the drip technique. Dilute the paint and apply it on to the pieces of paper on the canvas. When you do this, use a thick, rounded brush that can absorb large amounts of water. Allow the paint you have applied to trickle down the canvas. This will create paint trails. Guide the direction of the trails by tilting the canvas from side to side.
5. Repeat several times with darker colours to achieve tonal power.
6. Paint some areas with opaque paint to incorporate the collage paper and strengthen the composition. Think about the tonal contrast when you do this. The uniform areas bring calm to the image.

Demonstration paintings.

Right, paper collage using letter texture, 30 x 30cm (11¾ x 11¾in).

Below, acrylic on canvas, 30 x 50cm (11¾ x 19¾in), R. van Vliet.

STUDY 30 Collage with colour integration

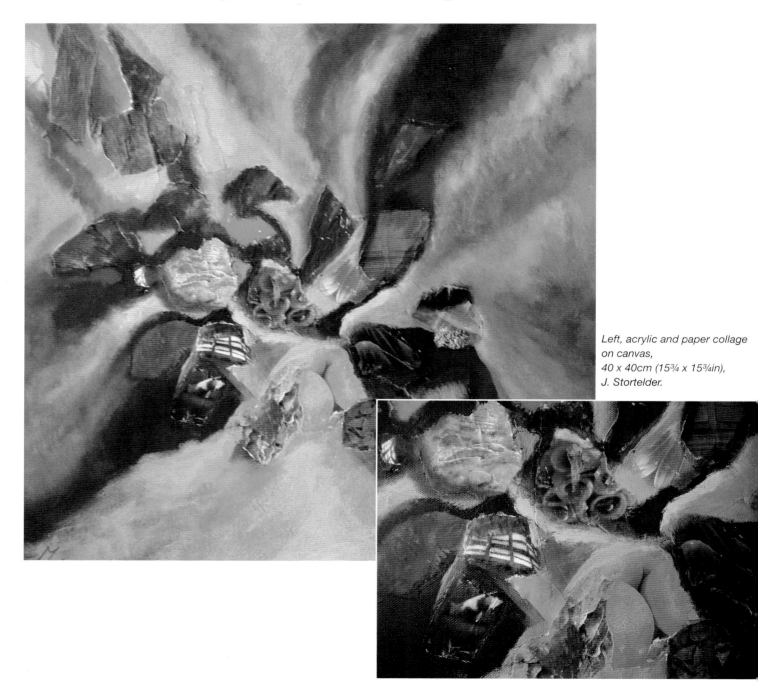

*Left, acrylic and paper collage on canvas,
40 x 40cm (15¾ x 15¾in),
J. Stortelder.*

Study task
Create a study in which pieces of paper from magazines determine the composition and further develop the work.
Materials
Canvas, acrylic paint, brush, images from printed paper in a suitable colour scheme, acrylic medium for the adhesive.
Techniques
Apply the collage technique and an integration technique. The idea is that the colours on the magazine papers are extended across the remainder of the work, causing the pieces to be fully incorporated. Use a covering method with opaque paint to smooth the surrounding space.
Visual elements
Shape, colour, tone, contrast, emphasis, dynamism, unity, harmony, direction, cohesion.
Composition
Use pieces of paper to create a composition that has a central focal point extending out to the edges of the canvas.

40 x 40cm (15¾ x 15¾in), S. van der Linden.

Work sequence
1. Find pieces of paper in complementary colours, tear into irregular pieces and attach to the canvas.
2. Choose paints which match the colours from these pieces so that the colours extend out from the paper to the immediate canvas surroundings. Continue working right up to the edges of the canvas. Thus incorporating the pieces of paper.
3. To finish off, add further colour emphasis to enhance the work.
4. Introduce a sense of calm to the surrounding space by painting in further even colour fields.

STUDY 31 Collage using textile textures

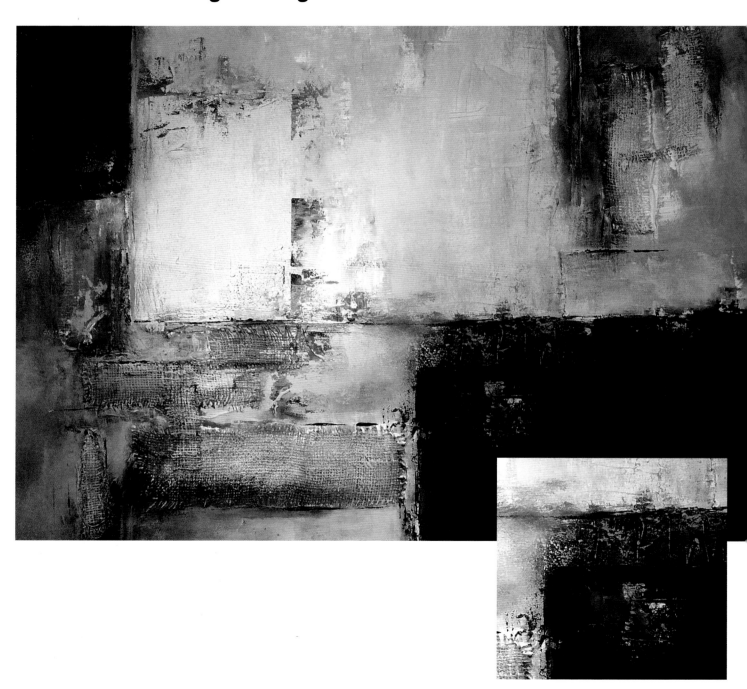

Study task

Create a work in which the structure of sackcloth and cotton determine the 'visual language' of the piece.

Materials

Canvas, acrylic paint, pieces of sackcloth and cotton, heavy gel as the adhesive, brush, palette knife.

Techniques

Apply the collage technique; attach the materials to the canvas using heavy gel or another strong adhesive; then use the knife-scumbling technique, thinly and lightly applying the paint. In addition, use the covering technique to connect the materials and the surrounding space using opaque paint. With this technique you can incorporate the materials into the paint layer. Use the dry-brush technique for the top layer, with a small amount of paint, and use the line-stamping technique for the detail (see p.120).

Visual elements

Line, shape, tone, format, texture, unity, balance, contrast, equilibrium, harmony, cohesion.

Composition

Use a design with rectangular shapes in horizontal and vertical equilibrium as your starting point.

Work sequence

1 Sketch the plane division on to the canvas.
2 Finish the composition by distributing the textile pieces evenly across the canvas.
3 Firmly attach the pieces on to the canvas and allow everything to dry.
4 Introduce the colour fields using the brush and/or knife.
5 Incorporate the textile pieces into the paint layer using both opaque and transparent thin paint.
6 Introduce the texture effect details to strengthen the unity and cohesion between the textile and the surrounding area.
7 You can also stamp on some line features to finish off the work.

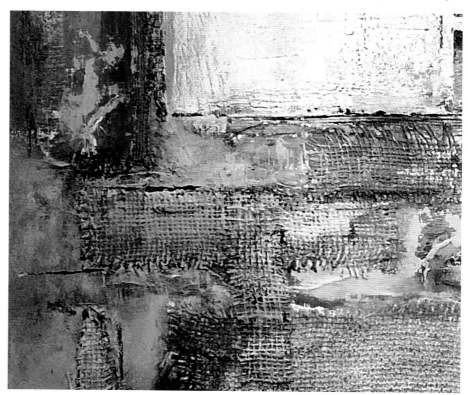

Acrylic and textile collage on canvas, 70 x 90cm (27½ x 35½in), P. Wiekmeijer.

STUDY 32 Pattern printing

Acrylic on canvas, 30 x 30cm (11¾ x 11¾in).
Variation on Picasso by G. Zwarts.

Study task
Create a work with an image as the background and use the integration technique with a pattern print.
Materials
Canvas, acrylic paint, embossed patterned wallpaper, black-and-white image copied on to printer paper, brush.
Techniques
Apply the collage technique in which the chosen image is stuck to the canvas using acrylic medium. Apply a printing integraion and glazing technique to introduce patterns to the entire area.
Visual elements
Shape, pattern, rhythm, colour, texture, harmony, unity, cohesion.
Composition
Figurative images determine the position of the image plane. In this case, we will place the image in a central position, but just away from the middle of the canvas.

Work sequence
1 Print an image in black-and-white on to printer paper.
2 Attach the full image to the canvas using a transparent adhesive.
3 Paint the surrounding space in the same hue as the image, incorporating the paper on which the image is printed. This step should integrate the paper into the paint layer and as a result the image will no longer appear to have been stuck on.
4 Use the embossed patterned wallpaper to print on to the surface with paint. Print with this two or three times on different places.
5 On top of these stamped prints, apply a second and third weaker print to cover the image.
6 Glaze the entire canvas in one colour to enhance cohesion in the work.
7 You can also finish off the work by painting a border around the painting.

Variation
Try applying a second (fainter) and even third print over the original image and integrate. Make sure to print over the original image using a faint print.

When you use an image from an existing painting you should always mention this in your presentation as follows: 'Variation on...by...' and then your name.

Demonstration painting. Variation on Rembrandt. Acrylic on canvas, 30 x 30cm (11¾ x 11¾in).

STUDY 33 Aluminium foil texture

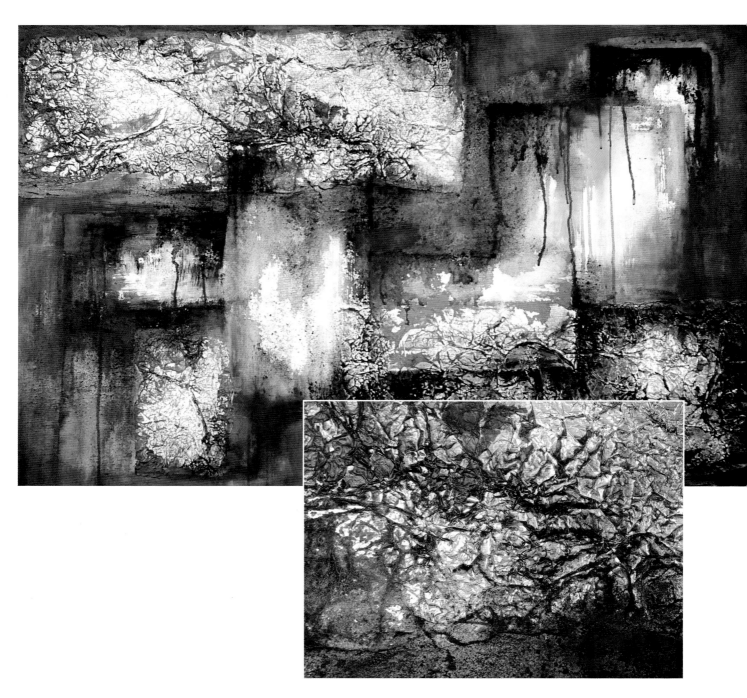

Study task
Create a work in which the shape and texture is determined by aluminium foil.
Materials
Canvas, acrylic paint, brush, aluminium foil.
Techniques
Apply the collage technique using crumpled aluminium foil stuck on to the canvas; the glazing technique with watery paint; the drip technique and dry-brush technique using opaque paint along the raised parts of the foil.
Visual elements
Shape, colour, tone, texture, format, contrast, harmony, equilibrium, cohesion.
Composition
Compose a design with rectangular shapes in horizontal and vertical equilibrium.

Work sequence
1 Tear up several rectangular pieces of aluminium foil, crumple them and stick on to the canvas, pushing firmly on the crumpled parts.
2 Glaze the entire area with two different colours. Allow other new rectangular shapes to emerge that can link the aluminium shapes to each other.
3 Allow the work to dry.
4 Glaze using a darker, more concentrated colour and leave droplets of paint in several areas.
5 Use the dry-brush technique to apply pure, dry paint to the raised parts of the crinkles in the foil.

Acrylic on canvas with kitchen foil as the characteristic texture.
70 x 100cm (27½ x 39½in), C. Ruijters.

111

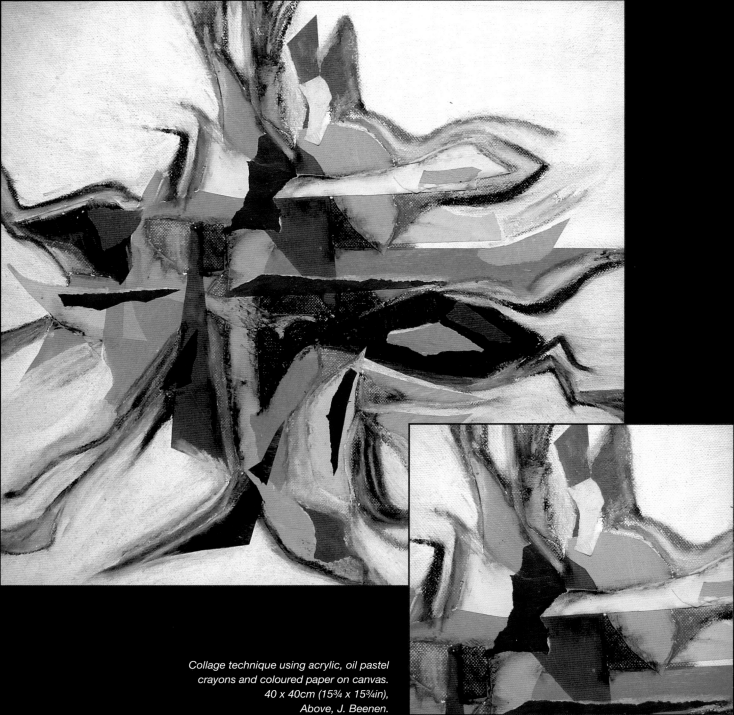

Collage technique using acrylic, oil pastel crayons and coloured paper on canvas. 40 x 40cm (15¾ x 15¾in), Above, J. Beenen.

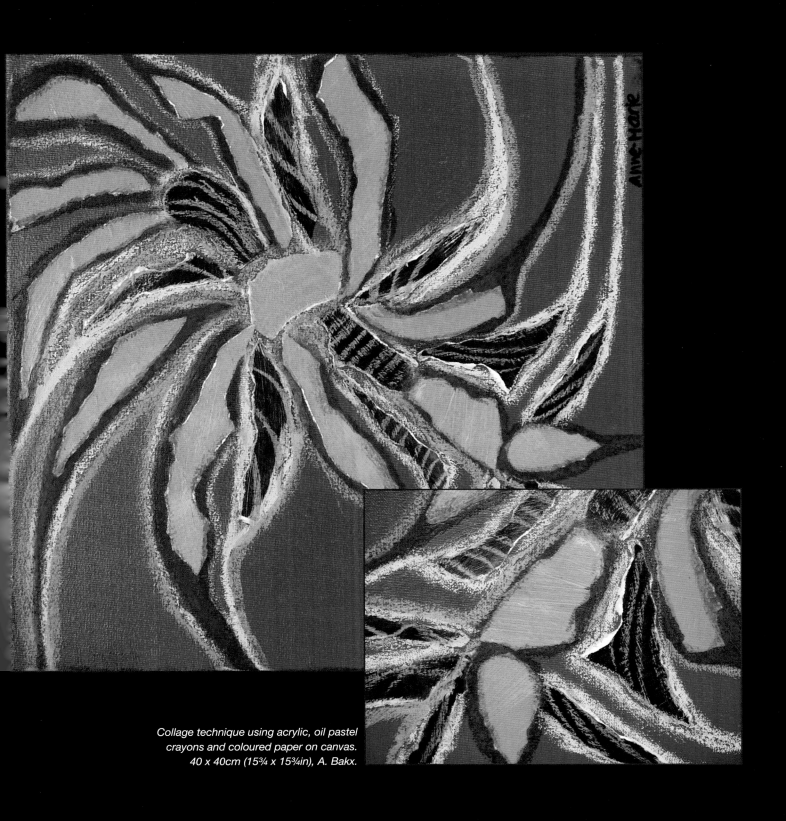

Collage technique using acrylic, oil pastel crayons and coloured paper on canvas. 40 x 40cm (15¾ x 15¾in), A. Bakx.

Drawing, sketching and line techniques

Drawing is an essential and basic skill even for abstract painters. When you use abstraction, you need to know your object well in order to be able to portray it in a convincing way. A clear figurative drawing is the starting point for your abstraction.

In addition to drawing, it is also important for you to master sketching. When we talk about sketching, we mean that the line does not completely and exactly show the shape; it is merely suggestive, sometimes with a hatched effect and often with angular line sections. It is less figurative, has less detail and is general and abstracted. For abstract painters, sketching is a more instinctive and more personal way of working.

You can introduce lines to the canvas using materials such as pencil, pastels, oil pastel crayons, felt tips, Conté crayons, charcoal, markers and other similar materials. You can also inject expressive linear effects using paint and special techniques. Consider the following:

- pouring or spraying liquid paint (A,H)
- fine paint brush and ink (C)
- paint and brush (D) and alla prima (I)
- paint and palette knife (B)
- masking fluid (G)
- foam brush or roller (F)
- line stamping technique (E).

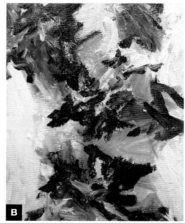

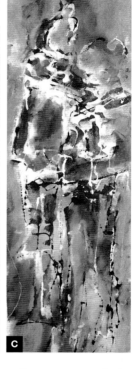

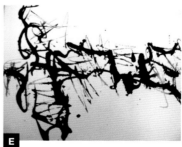

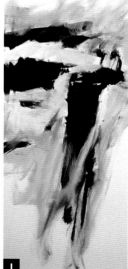

ine techniques

Depending on the materials and the way you choose to work, you can achieve a number of specific and distinctive effects. This gives abstract painters an important chance to find their own 'visual language'.

Think about line effects, using:
- line stamping technique, with card or a knife (B,F)
- negative, unpainted lines (H)
- positive lines, with varying thickness (D)
- graphic lines, by means of covering with tape
- poured or sprayed lines
- lines with the wax-resistant technique, using masking fluid or pastels (E)
- scratched lines, sgraffito (A)
- lines using the drip technique (C)
- scored lines, giving a deep relief effect (G)
- poured lines using transparent adhesive as a covering technique (I).

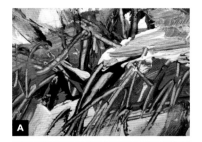

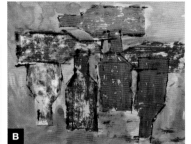

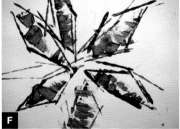

STUDY 34 Negative-line technique

Acrylic on canvas, 30 x 30cm (11¾ x 11¾in),
J. Zweijtzer.

Study task
Create a work that emphasises line rhythm using the negative-line technique.
Materials
Canvas, acrylic paint, brush.
Techniques
Use the negative line technique. Do not actually paint the lines, but let them appear from behind so that they stand out. Build up the work in layers.
Visual elements
Line, colour, tone, rhythm, pattern, repetition, dynamism, variation, unity, cohesion, harmony.
Composition
Divide the plane using various random, wavy lines that intersect each other. You will introduce the remainder of the lines during the painting process.

Demonstration of the line build-up. Layers 1, 2 and 3, J. Zweijtzer.

J. Meijer

Work sequence
1 Begin with a dark underpainting.
2 Mix the dark colour with a little white and paint in the areas between the imagined lines. When you do this, leave the lines unpainted. You will be able to see the outlines emerge in the darker, original colour of the underpainting.
3 Repeat this process two or three times. Once again, vary the colour and leave narrow areas unpainted. In this way, further thin lines will seem to appear in the depth. Do not forget to leave the existing lines as they are.

Variation
You can apply these steps by working from dark to light colours and from light to dark.

STUDY 35 Drawing with an atomiser

Study task
Create an abstract work that starts out with a sprayed line drawing.
Materials
Canvas, acrylic paint, brush, atomiser with liquid paint, spray bottle.
Techniques
Apply the sketching technique using liquid paint in an atomiser; use the brush technique using pure paint; and the drip technique.
Visual elements
Line, shape, tone, texture, contrast, dynamism, unity, harmony.
Composition
Position the shape in the centre, and work in close-up.

Work sequence
1. When you want to focus on a portrait, start by sketching a number of preparatory studies since the application technique must be performed quickly and in a sketching style.
2. Start with an underpainting using white paint.
3. Sketch out the shape using an atomiser with black or brown watery paint. If necessary, apply extra water using a spray bottle to encourage the formation of trail marks on the lines.
4. Work using white paint and brush across the entire canvas. Try to leave decorative lines and remove any excess lines. Work wet-on-wet. In this way the white paint takes the colour of the lines to the surrounding areas.
5. You can also add emphasis lines to the work.

Acrylic on canvas,
100 x 100cm (39½ x 39½in), R. van Vliet.

STUDY 36 Shape and line-stamping technique

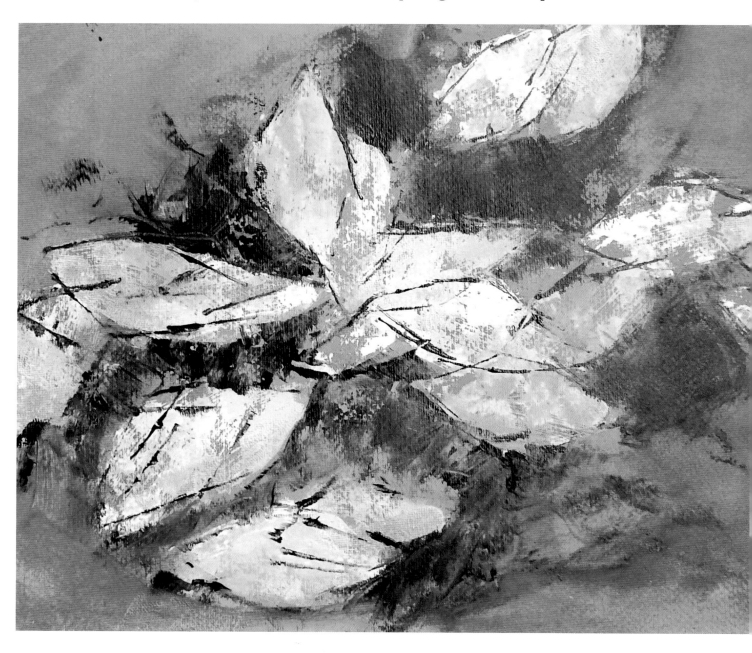

Study task
Create a work using stamped lines to accentuate shapes.
Materials
Canvas, acrylic paint, brush, a thick piece of cardboard.
Techniques
Apply a printing integration technique, in which you cut the shapes from cardboard and use these for the print stamps. Use the line-stamping technique with the double-folded edge of a piece of cardboard applying pure, undiluted paint to emphasise and strengthen the shapes. Use the smoothing technique for the surrounding space.
Visual elements
Line, shape, colour, tone, texture, rhythm, repetition, dynamism, unity, cohesion.
Composition
Design a focus composition using shapes from nature, for instance leaf shapes. Spread the shapes freely over the plane.

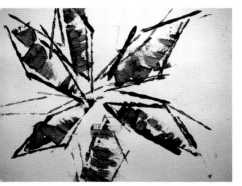

Work sequence
1 Start with a free underpainting and leave the work to dry.
2 Use a cut-out shape of cardboard to add overlapping and intersecting print stamps to the canvas in various colours.
3 Add emphasis to the contours using stamped lines.
4 To finish off, paint the remaining space and introduce calm to the surrounding areas.

Variation
Start your work using stamped shapes and then introduce the paint.

Line-stamping technique. Acrylic on canvas, 50 x 60cm (19¾ x 23½in), R. van Vliet.

STUDY 37 Sketching using a palette knife

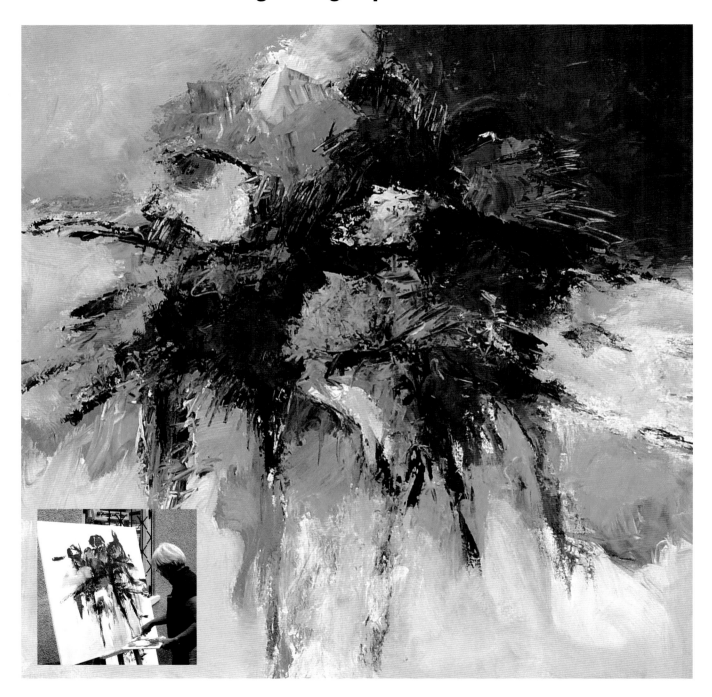

Study task
Create a impromptu sketch on the canvas using a palette knife and paint; complete the work with colour and texture.

Materials
Canvas, acrylic paint, brush, palette knife, spray bottle.

Techniques
Apply the knife technique for introducing lines and colour. Apply the sgraffito technique on the wet canvas, making score marks in the paint to introduce further texture. Use paint to smooth calm areas in the surrounding space. Make use of the drip and line-stamping techniques as well.

Visual elements
Line, shape, colour, tone, texture, format, contrast, dynamism, cohesion, unity.

Composition
Create a composition with a central, active focal area and a calm, passive surrounding space.

Work sequence
1 Use a knife and paint to instinctively sketch the composition. Spray water over the composition, which will allow the wet paint to drip down.
2 Allow everything to dry thoroughly.
3 Apply colour in and around the shapes using the knife and paint. Also apply colour to the surrounding space and use the sgraffito technique to add extra texture.
4 Use the brush to paint the surrounding space with smooth and even areas around the edges and gradually focus more on texture and colour intensity.
5 You can also add stamped lines for emphasis.

Tip
Repeat these steps as a quick study. The sketching and finishing will look more spontaneous as you have less time to think and it will help improve your painting skills.

I created these studies during a demonstration to promote materials. For this reason, I made them without any advance preparation as quick, sketched studies.

Left, acrylic on canvas, 100 x 100cm (39½ x 39½in), R. van Vliet.

Right, 80 x 100cm (39½ x 39½in), R. van Vliet.

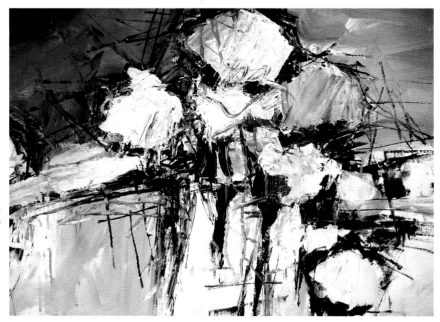

STUDY 38 Sketching using liquid paint

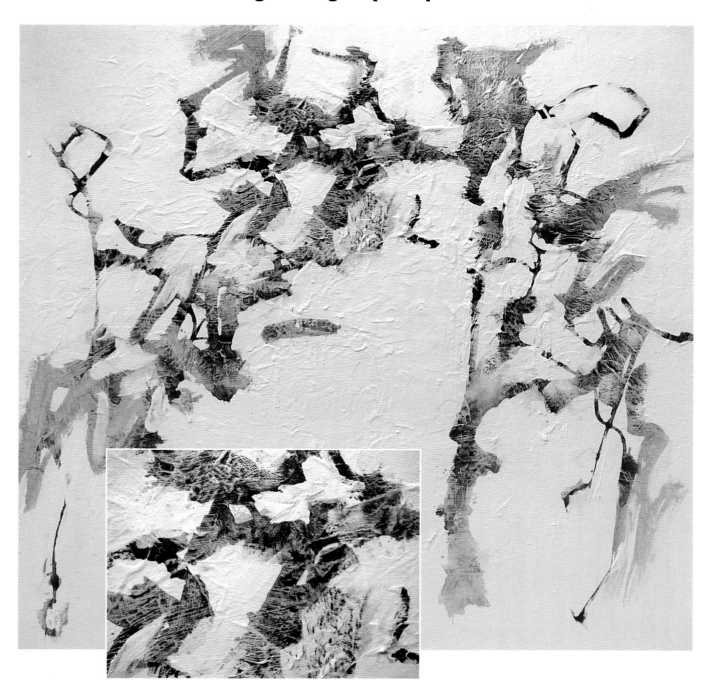

Study task

Begin your study with a rapid sketch by pouring liquid paint on to the canvas and working it over the whole canvas.

Materials

Canvas, acrylic paint, palette knife, brush, a watering pot or can with a narrow spout.

Techniques

By using the knife technique to create a lower layer, begin to apply texture to the canvas. Use the dry-brush technique for the top layer. Introduce the lines as spontaneously as possible. In the same way you may scribble a drawing on piece of paper, try pouring liquid paint from a thin spout working freely.

Visual elements

Line, texture, tone, contrast, dynamism, equilibrium, rhythm, repetition, emphasis.

Composition

Choose a plain division with a lot of free space. The jagged lines will create the image.

Work sequence

1 Apply white paint across the entire canvas using rough knife strokes. This will create an uneven surface. You can also add gel or modelling paste to the paint before you start.
2 Allow the canvas to dry.
3 Position your canvas on a horizontal angle.
4 Use a can to dribble paint on to the canvas in irregular lines.
5 Using a brush and clean water, smooth the paint from the lines towards the surrounding space. This will create regions of colour and paint strokes. You can also further dilute the paint you have applied, which will give additional trail marks (see illustration on right).
6 Allow the work to dry.
7 Subdue the contrast in several areas by stroking a dry brush with a small amount of light paint over the dark areas using the dry-brush technique.

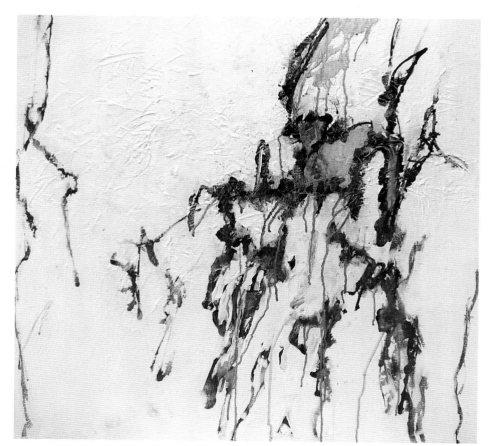

Sketch compositions. Acrylic on canvas, 80 x 80cm (31½ x 31½in), R. van Vliet (left and right).

STUDY 39 Lines in relief and rhythm

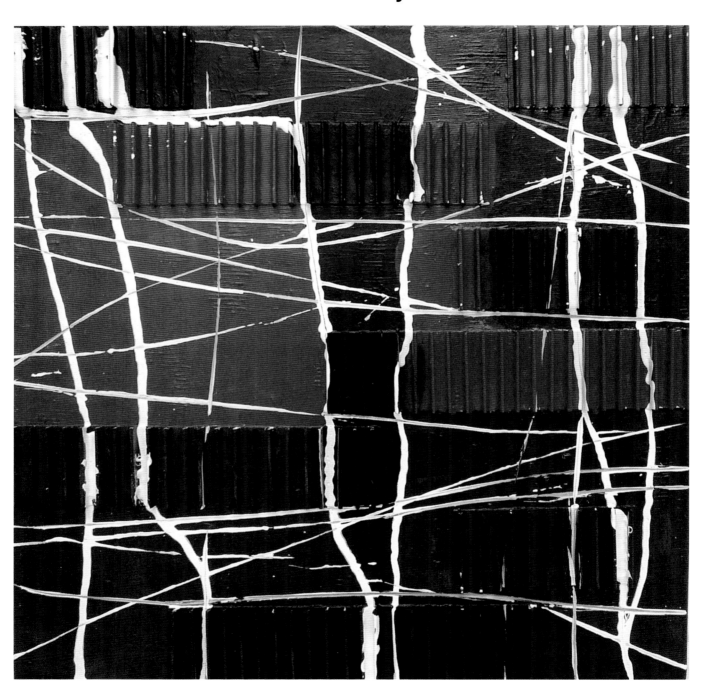

Study task
Create a work in which the collage material has relief and line effects.
Materials
Canvas, embossed materials, acrylic paint, brush, adhesive to attach the embossed materials.
If you use heavily embossed materials, work on a hard surface such as an MDF panel.
Techniques
Apply collage and the line techniques.
Visual elements
Line, colour, shape, tone, repetition, rhythm, equilibrium, variation, cohesion, unity.
Composition
Design the composition across the entire canvas area and pay attention to the equilibrium of the relief effect.

Work sequence
1 Use packaging materials with embossed, tactile lines. Cut the materials into usable shapes and stick these on to the canvas using a strong adhesive.
2 Apply colour to the entire area to incorporate the texture into the colour fields.
3 Paint lines on top of the work using a fine brush to bring life to this static image. When you do this, vary the thickness and direction of the lines. Your work now contains both tactile and visual lines.

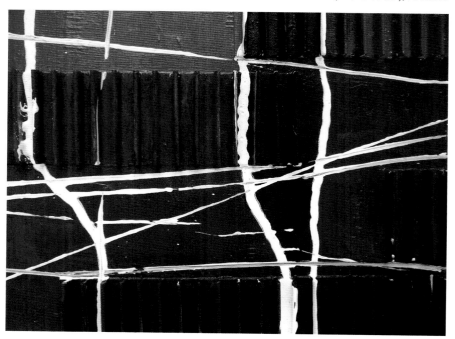

Acrylic and corrugated card on canvas,
50 x 50cm (19¾ x 19¾in), A. Bakx.

STUDY 40 Sketching with paint

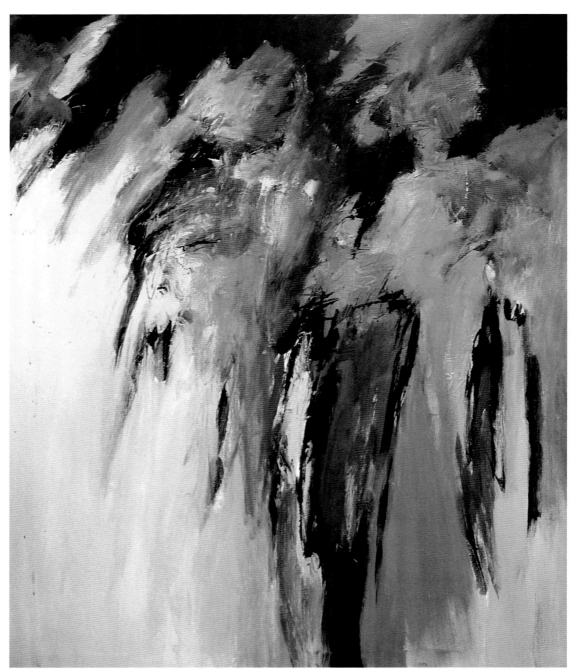

*Development of the paint sketch
shown on the right.
Acrylic on canvas,
80 x 100cm (31½ x 39½in),
R. van Vliet.*

Practice sketch in ink.

Work sequence
1 As a hand exercise, sketch out your theme several times using ink on paper.
2 Now, without any preparatory drawing on your canvas, sketch out the theme using a brush and paint on the canvas.
3 Use a sketch effect to add colour fields.
4 Apply the next layer, mix the colours and soften the roughness.
5 Finish off your work by covering it with textures using the brush and introducing calm to the surrounding space.

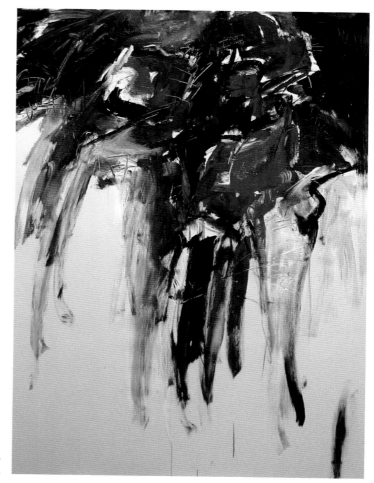

Demonstration paintings. Acrylic on canvas, 80 x 100cm (31½ x 39½in), R. van Vliet.

STUDY 41 Lines using the wax-resist technique

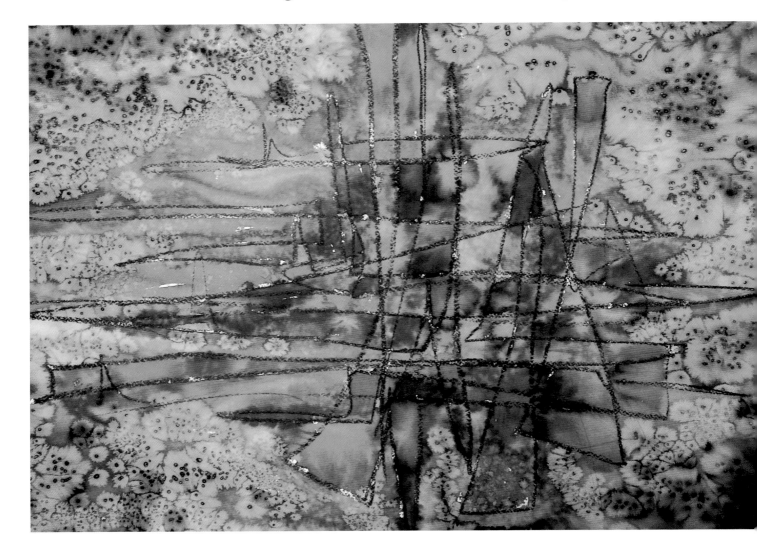

Work sequence

1 Apply your composition to the paper and cover the lines with masking fluid.
2 Allow the work to dry.
3 Apply colour to the entire area using liquid paint and build up the layers.
4 Allow the work to dry again.
5 Remove the masking film by rubbing off the dried masking fluid.
6 Colour the lines in a light hue using the glazing technique.

Study task
Use a variety of materials that repel paint to show lines in combination with watery paint.
Materials
Paper, liquid acrylic paint, oil pastel crayons, masking fluid, sea salt.
Techniques
Apply the flow-painting technique and a covering technique using oil pastel crayons. The crayons contain oils, which repel the liquid paint. As a variation, use masking fluid where the paper is covered and does not absorb any paint. Use sea salt for the texture. This absorbs the moisture wherever it is placed and will produce interesting effects.
Visual elements
Line, shape, colour, format, texture, cohesion, unity, dynamism, variation, emphasis.
Composition
Design a composition with a central focal area, radiating next to the middle and shapes that extend to the edges of the canvas.

Acrylic on canvas, 50 x 60cm (19¾ x 23½in), demonstration paintings, R. van Vliet.

Variation
1 Create a composition drawing using oil pastel crayons.
2 Apply colour to the entire area using liquid paint and build up the layers.
3 Sprinkle sea salt into the paint while it is still wet.
4 Leave the work to dry and then brush off the dried sea salt.

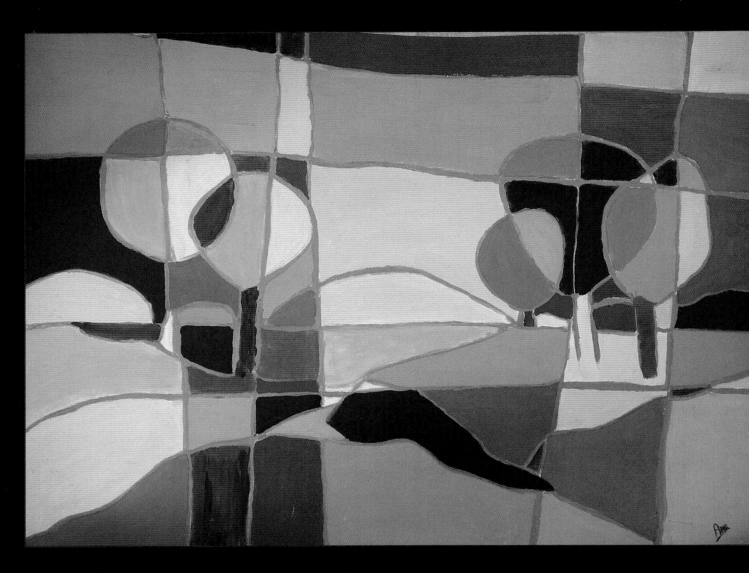

Negative masked-out lines.
An abstracted landscape in a double-line composition. The lines are left out
during painting which gives a whimsical and decorative effect.
Acrylic on canvas, 50 x 65cm (19¾ x 25½in), A. de Groot.

Positive graphic line.
Abstracting a still life by showing the shapes as a flat surface. In this way, the shapes are superimposed using a straight, graphic contour line. The wide contour accentuates the image apply these lines with a brush on top of the work as a finishing touch.
Acrylic on canvas, 60 x 80cm (23½ x 31½in), A. de Groot.

Mixed techniques and freestyle painting

When we think about mixed techniques, we think about working with a variety of materials. All of the ways in which we add substances such as sand, sawdust, clingfilm, paper, textiles or other collage materials can also be called mixed techniques. Combinations with crayons, ink, watercolour paints, oil paints and other such materials are also known as mixed techniques:

- working with textiles (A,B)
- using paint and French chalk powder (C)
- combination of paper and crayon (H)
- combination of texture paste and aluminium foil (I,F).

Freestyle painting

In addition to working with various materials, we can also think about using different techniques or actions with the same material. This way of working is frequently used by painters who are looking for freedom. In my lessons, I use the term **'freestyle painting'**.

This type of study task is especially suited to practising instinctive techniques and using your own discoveries. It is optimal freedom because anything and everything is possible. You can brush, shade, drip, splash, score, pour, in short, create chaos! After this comes the most difficult stage in this type of painting process, selecting what can stay and what should be removed and covered.

- freestyle with just paint (D,G),and with added substances (E).

A

B

C

D

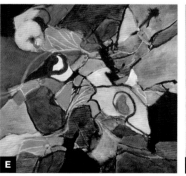
E

F

G

H

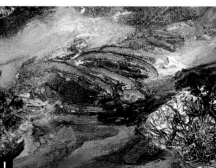
I

astel crayon technique

nteresting effects can be achieved with oil pastel crayons
s a mixed technique, as well as with freestyle painting. With
astels you can:
- show line features and contours (D)
- mix colours on top of each other (F)
- use sgraffito by scratching away the crayon (C)
- use crayons as a wax-resistant and masking material
 since pastel crayons are oily, they repel the diluted acrylic
 paint and create unusual textures (B)
- painting by spreading out the pastel layer using a brush
 dipped in turpentine (A).

Correction and covering techniques

rom time to time, when painting using acrylic paint, you will
ave to do corrective work. This is particularly the case with
reestyle painting as you need techniques to remove parts
o impose an order on the chaos. Incidentally, the correction
echniques can also leave behind extremely welcome
ositive effects.

ou can make changes to paint that has already dried by
oing the following:
- covering with opaque paint (G,H)
- gently rubbing with sandpaper
- masking with paper
- covering with oil pastel crayon.

ou can make changes to paint that is still wet by doing
he following:
- absorbing with a brush or cloth
- scraping with a palette knife (E)
- brushing with water and dabbing away
- absorbing with a sponge or printing tool, which will add
 texture. As with the tonkin technique, paint is lifted by
 placing a sheet of paper over a wet painting, rubbing a
 little and then removing the paper. You can also do this
 with cling film or pieces of cardboard. This action can be
 used to add shapes and textures.

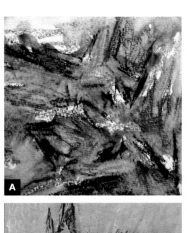
A

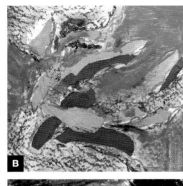
B

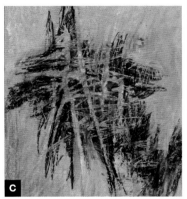
C

D

E

F

G

H

STUDY 42 Sandpaper texture

Mixed techniques.
Acrylic with a torn paper texture on canvas,
50 x 70cm (19¾ x 27½in), R. Eelsing.

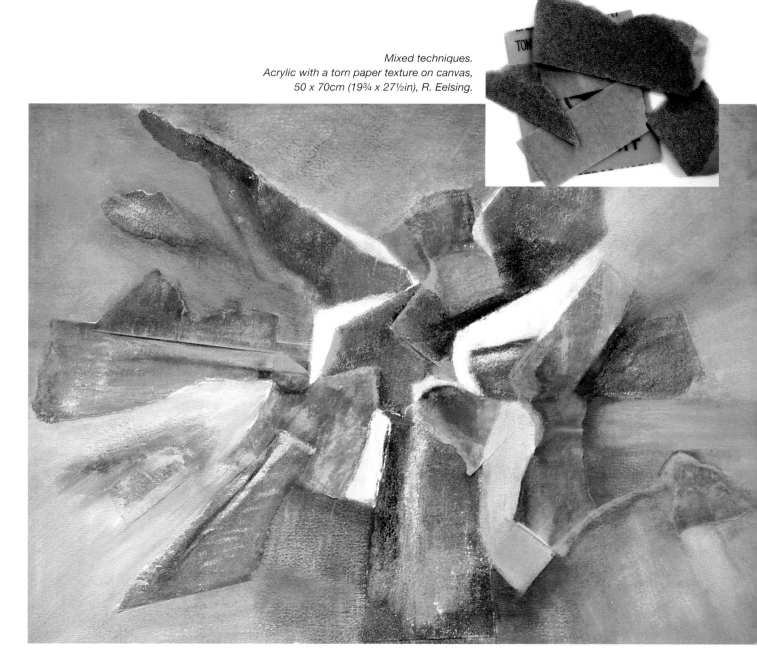

Study task
Create a work using sandpaper.
Materials
Canvas, acrylic paint, sandpaper, brush, heavy gel as adhesive.
Techniques
Apply the collage technique. Use a strong adhesive to attach the rough sandpaper. Use part liquid paint and part undiluted opaque paint to cover over the whole area.
Visual elements
Shape, colour, texture, format, tone, contrast, harmony, unity, cohesion.
Composition
Use torn and cut out pieces of sandpaper to design a composition with a central focal point.

Work sequence
1. Tear or cut a number of different shapes from the sandpaper.
2. Create a composition from the torn pieces. Think about equilibrium, variation and repetition of the format and texture.
3. Attach the pieces on to the canvas with strong glue.
4. Apply colour to the entire canvas, at first with a watery paint, then with a dry brush and undiluted paint. Incorporate the regions into the entire area by painting up to the edges of the canvas.
5. Introduce additional light and dark emphasis to reinforce the focal point.
6. Wherever possible, give the surrounding space a smooth, even appearance as a point of calm and to contrast with the texture of the sandpaper.

STUDY 43 Cling film texture and collage technique

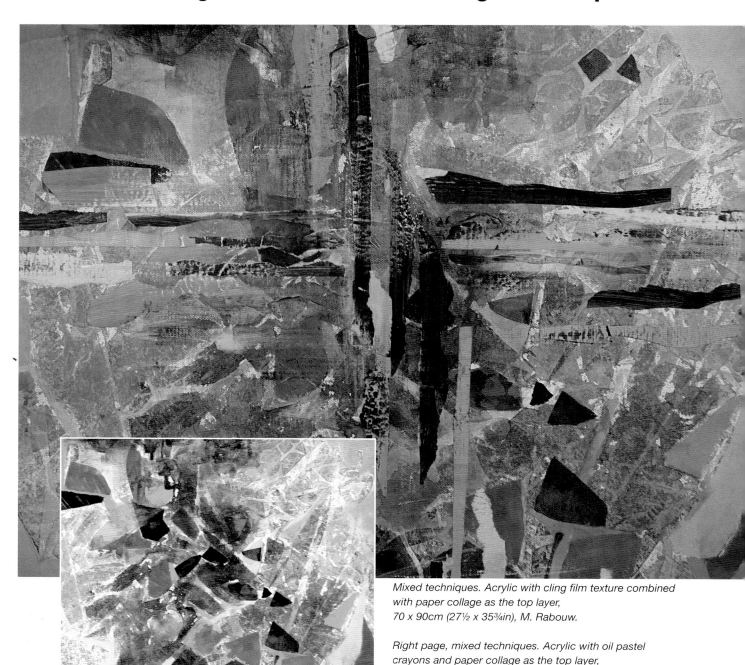

Mixed techniques. Acrylic with cling film texture combined with paper collage as the top layer,
70 x 90cm (27½ x 35¾in), M. Rabouw.

Right page, mixed techniques. Acrylic with oil pastel crayons and paper collage as the top layer,
60 x 70cm (23½ x 27½in), L. Sueters.

Study task
Create a work using clingfilm texture as the background and paper collage as the top layer.
Materials
Canvas, acrylic paint, brush, cling film, coloured paper, oil pastel crayons.
Techniques
Create a textured background by applying watery paint to the canvas and then covering with crumpled cling film, which will be removed completely after it has dried. Glaze the entire canvas. Paint out areas of the texture with opaque paint. Add emphasis by sticking coloured paper as collage materials on to the background. Apply the dry-brush technique using a dry brush and a small quantity of paint as the integration technique.
Visual elements
Colour, shape, line, texture, tone, variation, harmony, equilibrium, rhythm, unity.
Composition
The main composition will only be introduced at the end of the painting process. Choose a line rhythm that has horizontal/vertical equilibrium or choose to emphasise a vertical rhythm.

Work sequence
1 Cover watery acrylic paint in cling film to create a background. Allow the work to dry for a day and remove the cling film.
2 Apply a glaze to the entire canvas.
3 Paint areas of the work using opaque paint.
4 Introduce a composition with strips of coloured paper.
5 Use the brush and scuffed paint to brush paint over the covered areas to encourage cohesion and integration.

Variation
1 Work the background using paint and oil pastel crayons. Paint the colours into each other and mix these into various shades.
2 Stick the torn pieces of paper in a vertical rhythm over the background and emphasise the entire canvas with a pastel texture.

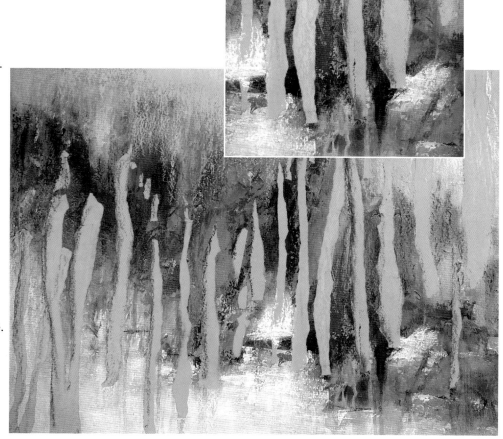

STUDY 44 Collage using mixed materials

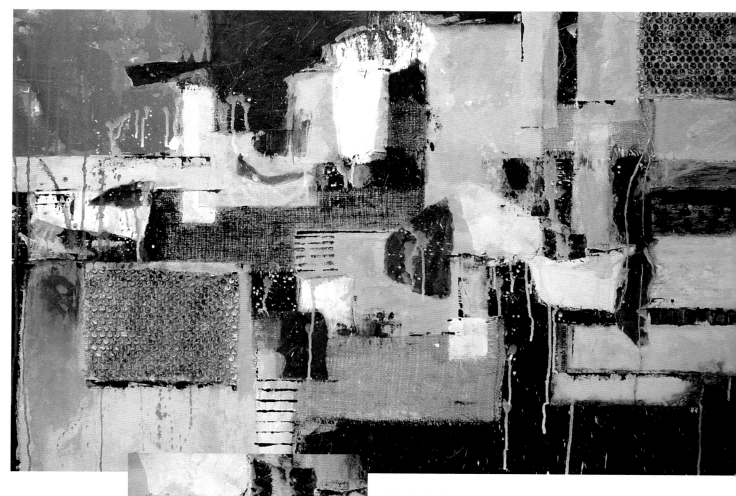

Mixed techniques.
Acrylic with various materials,
80 x 120cm (31½ x 47¼in), M. van Woudenberg.

Study task
Build up a work using various materials as collage.
Materials
Canvas, acrylic medium or another transparent adhesive, textiles with various textures, plastic, coloured paper, corrugated card, various strings and twines, paint, brush.
Techniques
Apply a collage technique; the drip technique; and an integration technique to bind the materials to each other and create unity.
Visual elements
Line, shape, colour, tone, format, texture, emphasis, contrast, equilibrium, harmony, cohesion.
Composition
Distribute the various textures evenly across the canvas, filling the entire area with materials.

Work sequence
1. Find materials that can add different textures and features to your work.
2. Cut or tear the materials into rectangular and free shapes of varying sizes.
3. Arrange everything on the canvas so the distribution is balanced.
4. Stick the first layer to the canvas and incorporating the pieces with a layer of paint.
5. Add a second layer of collage material and integrate this by painting between and over the materials.
6. Experiment with splatter and drip effects in the top layer to add emphasised features to your work.

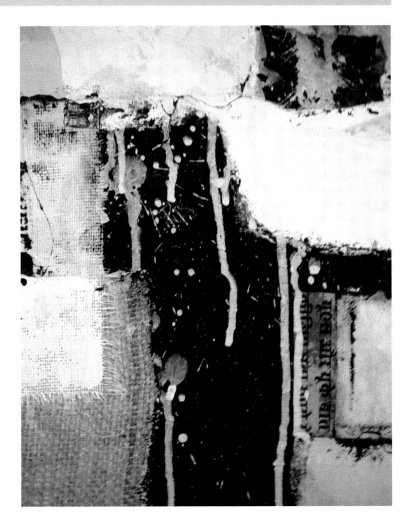

STUDY 45 Mixed techniques

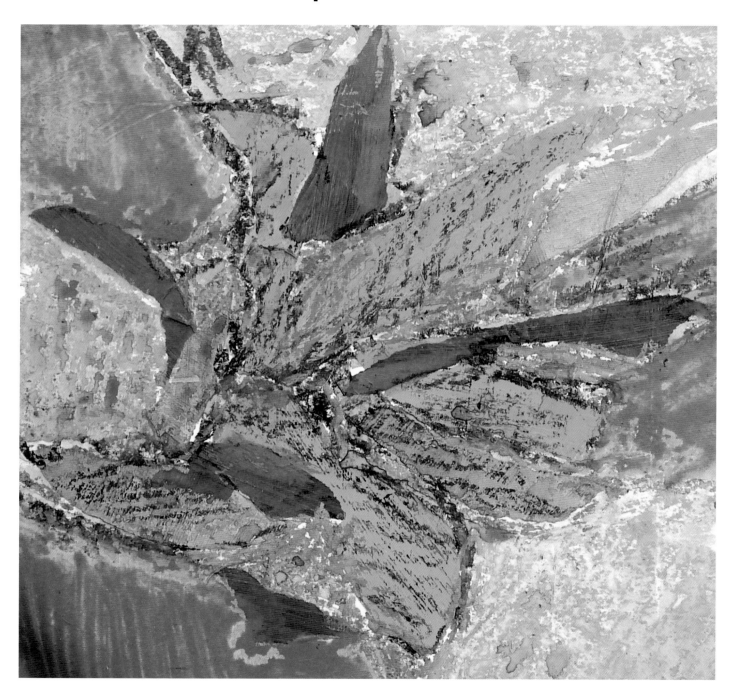

Study task

Create two quick studies using coloured paper stuck to the canvas and pastel crayon.

Materials

Canvas, acrylic paper, paper you have coloured yourself, acrylic paint, brush, oil pastel crayons.

Techniques

Apply a collage technique using the paper you have coloured. Stick the pieces on to the canvas using acrylic medium or another transparent and fast-drying glue. Apply a glazing technique using watery paint. Next use a texture technique using oil pastel crayons, by introducing lines with the tip of the crayon and coloured areas with the side of the crayon.

Visual elements

Shape, colour, line, texture, format, tone, emphasis, harmony, dynamism, unity, cohesion.

Composition

Design two different compositions with a central focal point.

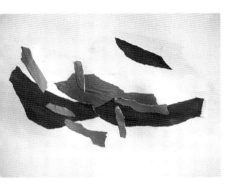
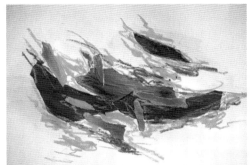
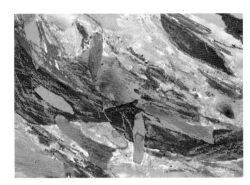

Work sequence

1 Prepare the pieces of coloured paper.
2 Tear and stick the pieces on to the canvas.
3 Apply oil pastel crayon to several of the pieces. This will add texture to a smooth surface.
4 Glaze the remaining shapes and the pastel crayon sections using watery paint. Since the oily crayon repels paint, this will create an irregular area of colour.
5 For tone and contrast, add several features using the crayons.
6 Finish off by applying opaque paint to some of the areas.

Demonstration painting.
Mixed techniques, paper, chalk and acrylic on canvas,
30 x 30cm (11¾ x 11¾in), R. van Vliet.

STUDY 46 Freestyle painting

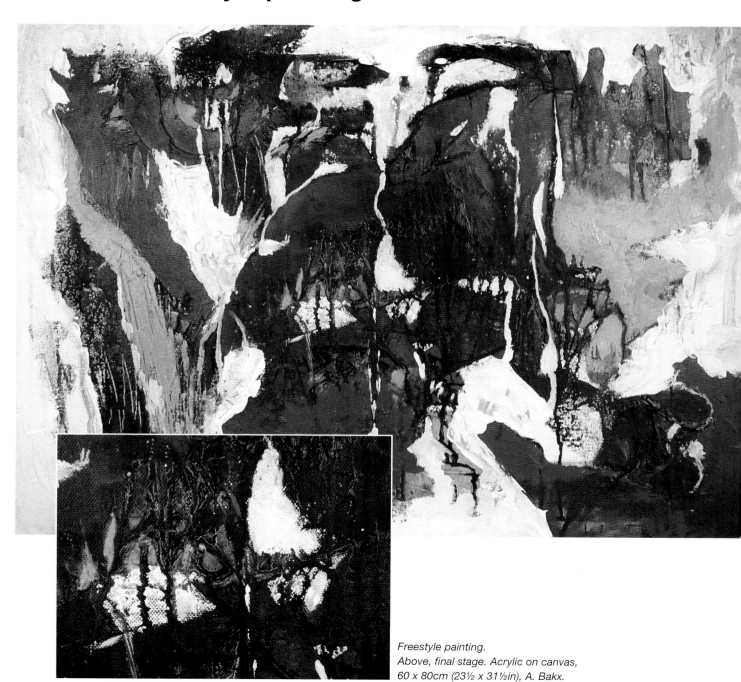

Freestyle painting.
Above, final stage. Acrylic on canvas,
60 x 80cm (23½ x 31½in), A. Bakx.

Study task

Create an experimental work using a variety of techniques.

Materials

Large format canvas, acrylic paint, sand, brush, palette knife, spray bottle containing water for the drip effect.

Techniques

In principle with a freestyle work, you can use any techniques, including the water-based techniques, such as drip and flow-painting; application techniques, such as knife-scumbling and sgraffito; covering and smoothing techniques with opaque paint. Try working with a brush or knife and spreading paint using a sponge or cloth. Feel free to use any technique that comes to mind. Use the covering technique to bring calm and order to the work (see p.53).

Visual elements

Line, plane, colour, tone, format, texture, dynamism, emphasis, contrast, harmony, cohesion.

Composition

The experimental techniques you use are key to determining the division of the composition. To get the best result from this method, use the entire canvas.

Work sequence

1 Paint the background in any texture by introducing modelling paste, gel, sand or tracing paper in certain areas. You can also begin without any texture as many techniques that you will work with can already achieve interesting effects.

2 Try to use as many techniques as possible, which can each play a role in bringing variation in texture and visual effect.

3 The finishing stage of a freestyle work is often a lot more difficult. You have to select what can stay and what has to be painted over and removed using opaque paint. At this point, are essentially emphasising the final composition.

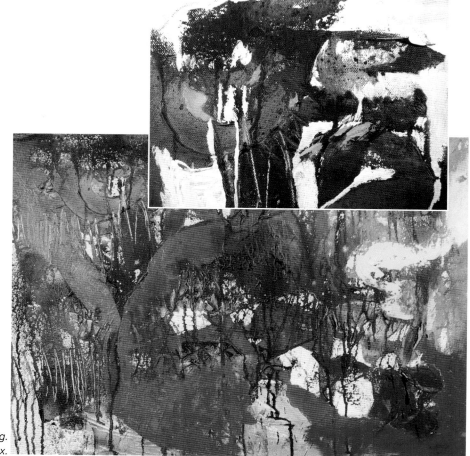

Right, build-up stage. Freestyle painting. Acrylic on canvas, 60 x 80cm (23½ x 31½in), A. Bakx.

STUDY 47 Freestyle techniques

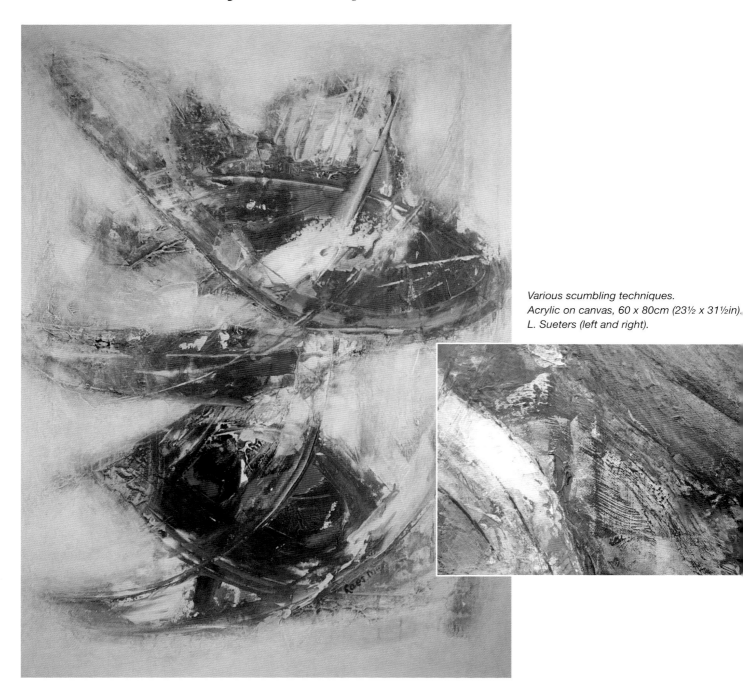

Various scumbling techniques.
Acrylic on canvas, 60 x 80cm (23½ x 31½in).
L. Sueters (left and right).

Study task

Create a freestyle work using various experimental techniques such as knife-scumbling, brushing, scratching, etc.

Materials

Canvas, acrylic paint, brush, cloth for wiping, palette knife for scraping, crayons, etc.

Techniques

Brush, scrape, score, scratch and shade many layers on top of each other producing a vivid effect, the combination of which will give the work a characteristic appearance. Apply a covering technique with opaque paint for the remaining canvas.

Visual elements

Line, shape, texture, colour, tone, dynamism, harmony, cohesion, emphasis, variation.

Composition

Allow the composition to develop during the freestyle process and only choose the shapes and plane divisions at the end.

Work sequence

1. Since no composition has been specified, start by freely and intuitively applying paint using the knife and/or brush. For each colour, introduce shading and colour areas and mix on the canvas.
2. Cover the entire canvas with colour. Mix the blues with white to introduce variety among the blue colours. Follow your intuition.
3. Think about variation by introducing different textures that will enliven the image.
4. Use white paint in the final stage to cover areas with paint. This will give further emphasis to the important textures.

STUDY 48 Freestyle using textiles

Study task
Create a work in which textile fragments create the 'visual language' of the piece.
Materials
Canvas, acrylic paint, brush, acrylic medium or gel, textiles with an open structure.
Techniques
Apply a collage technique to attach the textiles to the canvas after treating the materials in your own personal way.
Choose materials with an open structure for this work. Glaze the work for the first stage of integration. Continue working the canvas with both opaque and scuffed paint in order to achieve unity and cohesion.
Visual elements
Line, shape, format, colour, tone, texture, variation, unity, harmony, cohesion.
Composition
Use a composition with a central focal point and passive surrounding space to bring calm to the image.

Work sequence
1 Find materials with an open structure and make them your own by pulling out threads, cutting and tearing the material.
2 Cover the canvas with a layer of acrylic medium or gel and fix the collage materials into this.
3 Leave to dry.
4 Apply a glaze to the entire canvas.
5 Continue to work the canvas with various colours and think about tone variation. Introduce soft mixtures and nuances by blending the paints.
6 Give line and colour emphasis where necessary.

Acrylic and textile on canvas,
60 x 60cm (23½ x 23½in), C. Goedvolk.

STUDY 49 Free 'visual language'

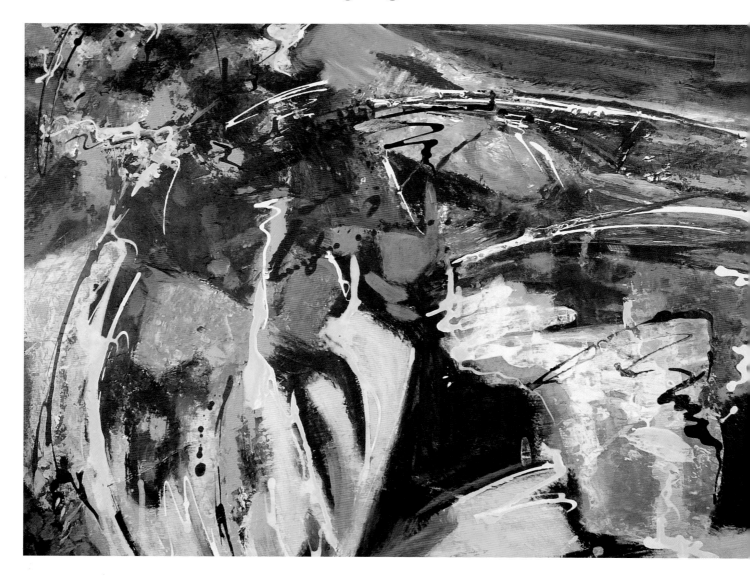

Study task
Use a variety of freestyle techniques to create the 'visual language' of a work.
Materials
Canvas, acrylic paint, knife, brush, atomiser, sand.
Techniques
Brush and shade with paint. Work with line effects from an atomiser, scrape with a knife, splatter and drip paint by shaking the brush above the work. Use all of the techniques that you know.
Visual elements
Line, shape, colour, tone, texture, dynamism, emphasis, contrast, harmony, variation, unity, cohesion.
Composition
Allow the plane division to emerge during the free painting process. First and foremost, the composition should display dynamism and movement.

Work sequence
1 Freely and instinctively distribute colour fields across the canvas and, if you prefer, add sand in certain areas to introduce extra texture.
2 Leave to dry.
3 Introduce a second layer of colour nuances.
4 Cover the empty surrounding space with a dark, uniform colour. This strengthens the contrast and cohesion.
5 Play with the lines that you draw using an atomiser and liquid paint.
6 Add splatter and drip effects with a brush containing wet paint.
7 Finish off with several features using opaque paint to create colour repetition and unity. Keep the colours pure by allowing the work to dry between coats.

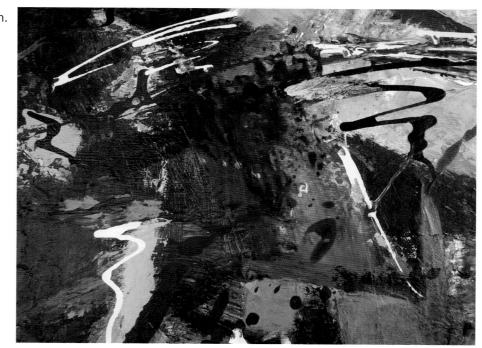

Freestyle painting. Acrylic on canvas, 60 x 80cm (23½ x 31½in), J. Holthe.

STUDY 50 Miscellaneous techniques

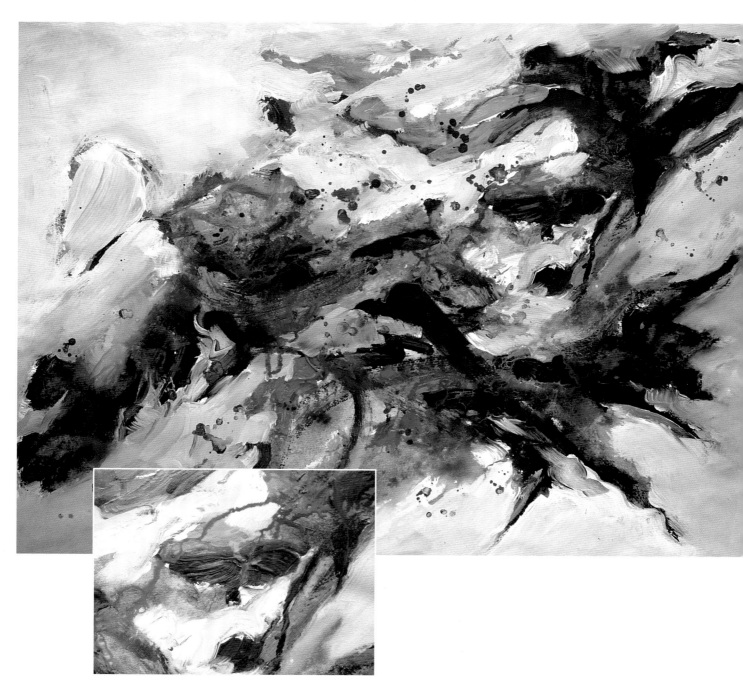

Study task
Create a freestyle study using a lot of dynamic features and techniques and bring calm to the 'chaos'.
Materials
Canvas, acrylic paint, brush.
Techniques
Apply various techniques using both thick and watery, pure paint. Apply optical and acrylic mixing; splash and drip techniques; and covering techniques painting over certain textures with opaque paint and adding calm to the active image.
Visual elements
Shape, colour, tone, texture, contrast, dynamism, emphasis, variation, unity, harmony, cohesion.
Composition
You do not need to create a composition before starting. A free start with a variety of techniques is more successful if a connection with particular shapes has not yet been established.

Work sequence
1 Start by applying several separate areas of pure paint. Work with a brush and water from one colour to the next and link the entire work using watery paint. This will create chemical mixtures.
2 Allow the work to dry.
3 Apply a second transparent layer of thin paint which will create optical mixtures.
4 Continue by adding colour features using opaque paint.
5 Finish off the canvas using opaque, white paint. Paint away areas to bring calm to the image. Using a covering technique, soften the transition between the colour and white.
6 Apply liquid paint splashes and drip paint to liven up the work.

Various techniques. Study to demonstrate covering technique.
Acrylic on canvas, 60 x 70cm (23½ x 27½in), R. van Vliet.

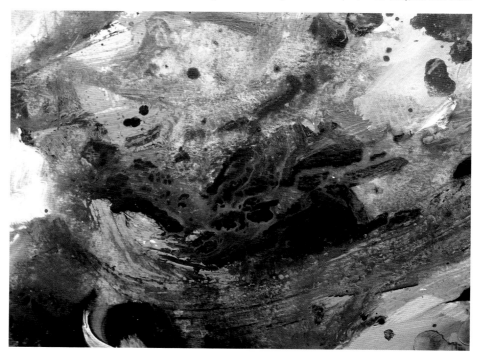

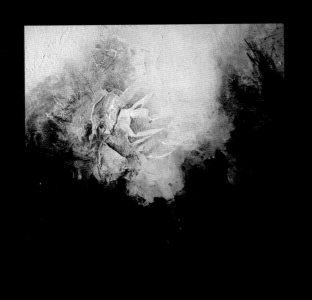
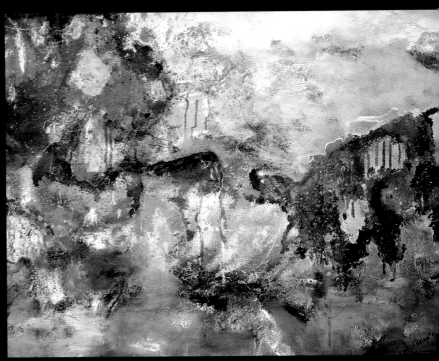
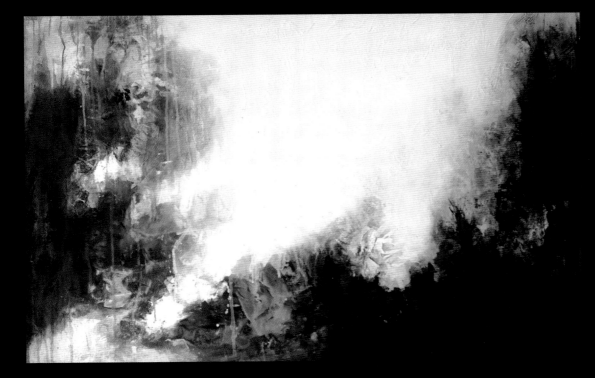

Working with the various techniques creates an original 'visual language'.

Above left, water-based techniques on a sand texture,
60 x 80cm (23½ x 31½in), R. Arends.

Below left, acrylic on canvas using printing and drip techniques as the 'visual language',
80 x 100cm (31½ x 39½in), L. Sueters.

Above right, layered work using knife scumbling and dry brush techniques,
50 x 70cm (19¾ x 27½in), L. Sueters.

12 Over to you

Having reached this point and followed all of the studies and techniques in this book, it will be easy for you to carry on by yourself.

You can now design your own studies based around visual elements, composition, techniques or texture. For example, try exploring concepts such as 'the interplay between acrylic and water, pastel and paint, line and rhythm, dynamism using a brush'. There are, of course, numerous conceptual triggers to get you started on a study. Each of them will stimulate the painting process and that is what it is all about; continuously practicing, discovering and creating. Over time you will develop and strengthen your skills and you will be able to instinctively hone your own artistic sensibility.

As I have focussed entirely on the technical aspects of abstract painting in this book, I have limited the information on general knowledge and composition. The benefit of this has hopefully been that the practical nature of the free-painting process is made more accessible to the reader. It is impossible to cover all techniques and textures in this book, and there are, of course many more to explore. When you take the time to experiment on a regular basis, you will discover these for yourself.

The techniques in these studies are simply a good starting point on the path towards free and abstract artistry. I have wanted to stimulate you in finding your own way, letting go of "what is" to create your own unique and original paintings that are full of thought, sensitivity and emotion. I have focussed especially on free and expressive techniques which, through experimentation and play, will enable you to recognise the development of your own artistic skill.

Remember to always distance yourself from what already exists and choose your own painting world that is unique to you.

Choose the abstract way and let the 'Abstract Painting Method' be your guide.

I wish you every success.

Rolina van Vliet.

Acrylic on canvas in a dynamic mixed technique with sgraffito features as the distinctive 'visual language', 80 x 80cm (31½ x 31½in), R. van Vliet.

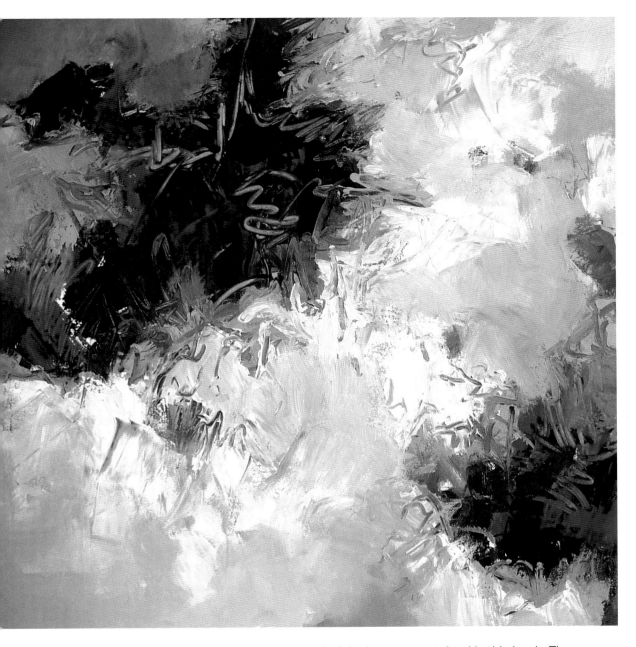

I personally devised the 'Abstract Painting Method' and all of the lessons contained in this book. They are a reflection of my experiences as a visual artist and teacher.

In addition to my own work, the majority of the images were created by my students. I would like to thank them for their cooperation. It is partly for this reason that this has also become an extremely varied book, from a technical perspective.

First published in Great Britain 2013 by Search Press Limited,
Wellwood, North Farm Road, Tunbridge Wells, Kent, TN2 3DR

Originally published in the Netherlands as
Abstracts, Het spel met techniek en textuur
by De FonteinTirion Uitgevers, 2012

Text and photography: © Rolina van Vliet
Cover design and book layout: Danny Dijkstra
Artwork: Rolina van Vliet

English translation by Giovanni Vinti for Cicero Translations Ltd.

ISBN 978-1-84448-955-8

Printed in China

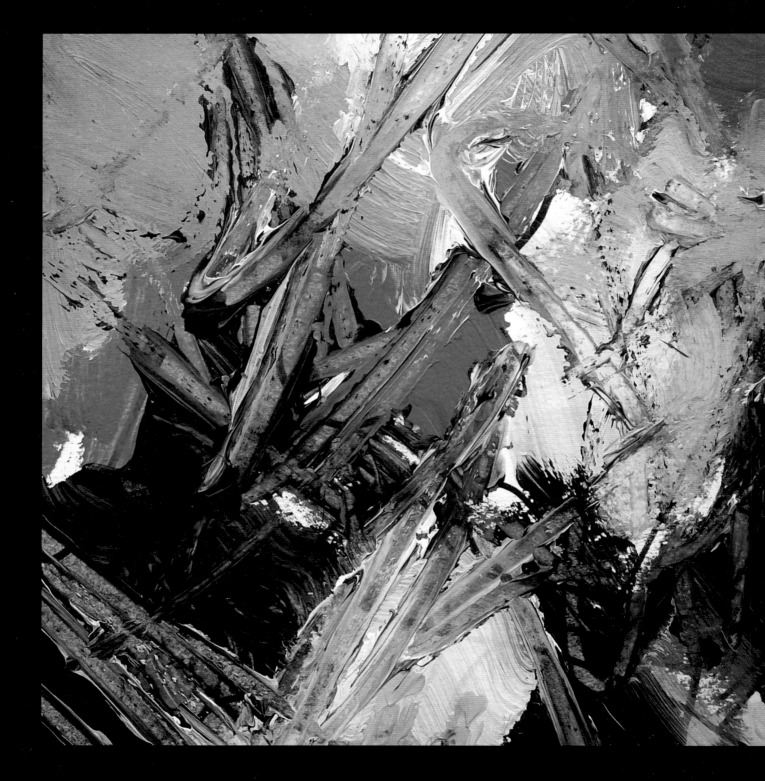